# A SHARED ELEGY

# A SHARED ELEGY

PHOTOGRAPHS BY

ELIJAH GOWIN

EMMET GOWIN

OSAMU JAMES NAKAGAWA

TAKAYUKI OGAWA

*Introduction by*
*Nanette Esseck Brewer*

*With essays by*
*Joel Smith and Yoshiko Suzuki*

Grunwald Gallery of Art
Sidney and Lois Eskenazi Museum of Art
Indiana University, Bloomington

This catalogue is published in conjunction with the special exhibition, *A Shared Elegy,* presented at the Grunwald Gallery of Art, Indiana University, Bloomington, October 13– November 16, 2017. *A Shared Elegy* was made possible by the College Arts and Humanities Institute, the Grunwald Fund, the McKinney Visiting Artist Series, the Center for Integrative Photographic Studies, School of Art + Design at Indiana University, and the Eskenazi Museum of Art. Additional support came in part from David and Martha Moore, David H. Jacobs, Nancy and Bill Hunt, Susan Thrasher, and Emmet and Edith Gowin.

Grunwald Gallery of Art
soad.indiana.edu/centers-galleries/grunwald-gallery
Betsy Stirratt, Director
Linda Tien, Program Coordinator
Hannah Osborn, Project Assistant
Chris McFarland, Project Assistant

Indiana University Sidney and Lois Eskenazi Museum of Art
www.artmuseum.indiana.edu
David A. Brenneman, Wilma E. Kelley Director
Nanette Esseck Brewer, Lucienne M. Glaubinger Curator of Works on Paper
Mariah Keller, Editor
Brian Garvey, Senior Graphic Designer
Printed in East Greenwich, Rhode Island, by Meridian Printing

Distributed by Indiana University Press, Office of Scholarly Publishing,
Herman B Wells Library 350, 1320 E. 13th Street, Bloomington, IN 47405-3907

Library of Congress Cataloging-in-Publication Data

Names: Gowin, Elijah, 1967- photographer. | Gowin, Emmet, 1941- photographer.
  | Nakagawa, Osamu James, 1962- photographer. | Ogawa, Takayuki, 1936-2008
  photographer. | Brewer, Nanette Esseck, writer of introduction. | Grunwald
  Gallery of Art, host institution.
Title: A shared elegy / Elijah Gowin, Emmet Gowin, Osamu James Nakagawa,
  Takayuki Ogawa ; introduction by Nanette Esseck Brewer ; with
  contributions by Joel Smith, Yoshiko Suzuki.
Description: Bloomington: Grunwald Gallery of Art, Sidney and Lois Eskenazi
  Museum of Art, Indiana University, [2017] | "This catalogue is published
  in conjunction with the special exhibition presented at the Grunwald
  Gallery of Art, Indiana University, Bloomington, October 13-November 16, 2017."

Identifiers: LCCN 2017026440 | ISBN 9780253032515 (alk. paper)
Subjects:  LCSH: Photography of families--Exhibitions.
Classification: LCC TR645.B576 G78  2017 | DDC 770.92--dc23
LC record available at https://lccn.loc.gov/2017026440

Cover (details, left to right): Plate 51, Elijah Gowin, *Divide I*; plate 63, Emmet Gowin, *Edith in Panama, Double Edith and Rothschildia*; plate 41, Osamu James Nakagawa, *Leaving Tokyo, Japan*; plate 33, Takayuki Ogawa, *Untitled 17*

# CONTENTS

# DIRECTORS' FOREWORD

*A Shared Elegy* brings together the work of four photographers, revealing intergenerational connections through two families of artists. Elijah Gowin, Emmet Gowin, Osamu James Nakagawa, and Takayuki Ogawa present unique but overlapping visions of family histories. While their images expose some cultural distinctions, these are overshadowed by moving similarities in the representation of principal life events, from birth and the raising of children to the connection with home, and ultimately to aging, illness, and death.

We acknowledge the artists James Nakagawa and Elijah Gowin, the driving forces behind the exhibition and this book, and we are honored to feature the work of Elijah's father, Emmet Gowin, and James's late uncle, Takayuki Ogawa. Their inclusion in the exhibition creates a genealogical context for the works of these accomplished younger artists.

This book and the accompanying exhibition are notable not only for the beautiful work of the photographers but also because they represent a special collaborative effort between the Grunwald Gallery of Art and the Sidney and Lois Eskenazi Museum of Art at Indiana University. Working together to highlight the work of these significant artists has been a distinct pleasure for both institutions.

Joel Smith's history of working with Emmet Gowin on previous projects makes his contribution to this book welcome and noteworthy. Yoshiko Suzuki, a writer and curator familiar with artists in both the East and West, has been particularly adept at discussing the spiritual nature of these photographs in her essay. Nanette Esseck Brewer, the Lucienne M. Glaubinger Curator of Works on Paper at the Eskenazi Museum of Art, provided the introduction, which puts the photographers' works in context.

We also gratefully acknowledge the artists and the Richard and Ronay Menschel Collection for lending these works, as well as the College Arts and Humanities Institute, the Grunwald Fund, the McKinney Visiting Artist Series, and the Center for Integrative Photographic Studies, School of Art + Design at Indiana University for making the exhibition and book a reality. David and Martha Moore, David H. Jacobs, Nancy and Bill Hunt, Susan Thrasher, and Emmet and Edith Gowin provided additional support for this unique and important project.

*A Shared Elegy* compels us to reflect on our own lineage and consider our place in the progression of generations. It also initiates a meaningful conversation about what unites us as human beings. The inspiring photographs often reveal the transcendent nature of family ties and the profound effects of these relationships on our sense of place and belonging, a universal aspiration.

Betsy Stirratt
*Director, Grunwald Gallery of Art*

David A. Brenneman
*Wilma E. Kelley Director,*
*Sidney and Lois Eskenazi Museum of Art*

# ARTISTS' ACKNOWLEDGMENTS

This book is dedicated to the memory of Takeshi and Yoko Nakagawa and Takayuki Ogawa. Special thanks go to Esa Epstein, Tomoko and Hikari Nakagawa, Wakako and Anri Ogawa, and Anne W. Tucker for their encouragement and support. Our warmest gratitude goes to Joel Smith and Yoshiko Suzuki for their essays and to Nanette Esseck Brewer for her introduction. We also acknowledge the assistance and support of Robert Mann Gallery, SepiaEYE, and Pace/MacGill Gallery, New York; PGI, Tokyo; and Pictura Gallery, Bloomington, Indiana. Our special thanks goes to Sarah Baghdadi, Sam Bodenstein, Simon McCool, and Ashlyn Reynolds for their assistance. At the Grunwald Gallery, we also thank Betsy Stirratt, Chris McFarland, and Hannah Osborn. David A. Brenneman, Brian Garvey, and Mariah Keller at the Sidney and Lois Eskenazi Museum of Art helped make this book a reality.

—Elijah Gowin, Emmet Gowin, and Osamu James Nakagawa

# INTRODUCTION

*"I feel that the clearest pictures were at first strange to me; yet whatever picture an artist makes, it is in part a picture of himself."* —Emmet Gowin, 1976

Philosophers in both the Eastern and Western traditions have long pondered the question of personal identity. In the current heated political climate, ideas about our sense of self, separate from our physical body, have gained new urgency. Many factors, including gender, occupation, family, friends, culture, spirituality, and environment, shape who we think we are. The four artists in this exhibition—Elijah Gowin, Emmet Gowin, Osamu James Nakagawa, and Takayuki Ogawa—use the camera lens to look beyond mere documentation and reveal what is in their minds and hearts.

Only one artist in the exhibition, the late Japanese photographer Takayuki Ogawa, produced straight self-portraits (albeit partially blocked by his hand [pl. 17] or interspersed with a flower [pl. 39]). Even when doing so, his primary concern was not his outward appearance, but capturing an egoless-ness, what Buddhists call the "not-self," or *anatman*. Not surprising, many of the images from Ogawa's late-in-life series, *Beyond the Mirror: A Self-Portrait*, reveal his body as a negative space—either as an X-ray or shadow. Although the rest of the photographers in this volume decline to show their physical selves, the factors that shaped their identity remain evident.

The most powerful and complicated identity-shaping agent is one's family. The history of photography features many familial connections—brothers working together, husband and wife teams, and artists utilizing their spouses and/or children as their primary muse. Emmet Gowin with his wife, Edith, and her extended family fall into the latter category (see pl. 9). Children of famous photographers succeeding in the profession in their own right are far less common. Not only have they absorbed the techniques and styles of their parents but they also share many of the same environmental stimuli. Elijah Gowin somehow managed to both embrace his heritage and forge a unique identity. For James Nakagawa, nephew of Ogawa, the challenge is not one of direct influence, but rather how to honor and preserve his uncle's legacy.

Cultural influences, whether associated with ethnicity, geographical roots, or even religious background, often appear in these artists' images through juxtapositions of parents and offspring. Intergenerational connections frequently result through a glance, touch, or ethereal light. The power of place, likewise, forms a central element for such bonds. Nakagawa, who frequently travels back and forth between the United States and Japan, titles the images in his *Kai* (meaning "cycle" or "the transmigration of souls"

in Japanese) series with the sites of their creation, as do Emmet and Elijah, particularly when the pictures are associated with their family's ancestral hometown of Danville, Virginia. However, it is not only locations connected with the past but also new places and experiences (as seen in Emmet's landscapes taken in Nevada, Washington, Italy, and Ireland) that affect how these artists see the world.

Spirituality appears in many forms throughout these works. Elijah imagines a "soul" floating as if to heaven (pl. 23), while Nakagawa envisions a bubble holding the spirits of his ancestors (pl. 81). In an interesting cross-cultural exchange, Elijah's use of fireflies recalls a Japanese concept that the insects' light represents dead souls, an idea that he discovered on a trip to Japan with his father in 2004 (pl. 20). A divine presence in nature—revealed through the elements (earth, water, air, and fire) and small natural details—permeates many of the artists' works.

The sequencing of these pictures—often by related theme, form, or mood—creates a portrait of four individual artists, as well as a metaphor for the broader human experience.

Nanette Esseck Brewer
*Lucienne M. Glaubinger Curator of Works on Paper,*
*Sidney and Lois Eskenazi Museum of Art*

# A SHARED ELEGY

Joel Smith

Would it matter, while looking at the photographs in this book, to imagine one artist made them all? To turn the question inside out: What does it mean to say that one body of art is "related" to another? And when genuine familial relation is involved, is it dubious—or altogether natural—to perceive a "family resemblance" between artworks made by related artists?

A Shared Elegy grew from a conversation between two artist friends. Osamu James Nakagawa (b. 1962) suggested to Elijah Gowin (b. 1967) an exhibition that would combine their photographs with those of James's late uncle, Takayuki Ogawa (1936–2009), and Elijah's father, Emmet Gowin (b. 1941). The project they embarked upon was experimental, in a musician's more than a scientist's sense of the word: they wanted to learn how it would feel to combine the artistry of four people who were linked in ways both known and unknown, received and chosen.

Casting a light on just one matchup between family members, whether uncle and nephew or father and son, would have posed a pretty simple equation. Doing it twice introduces a little breathing room, and at the same time raises another question: in the fast-changing world of the past century, might artists have more in common with their generational "brothers"—even those born half a world away—than with a flesh-and-blood relative raised in a different historical dynamic?

The four bodies of art winding through A Shared Elegy intersect on many levels. The artists all turn to nature both as a source of subjects and symbols and as the setting in which to make sense of their families and themselves. The ideas that animate their art are romantic, by today's measure, and they have been arrived at through work, rather than being left in charge of the art-making process. Certain shaping forces, too, show up repeatedly on these pages. Circles, for example, find many ways to arise: a bird's nest, a bomb crater, the blinding

disc of the sun, a bloom of blood in gauze, a drifting bubble (pls. 38, 40, 49, 68, 81), and, in some of Emmet Gowin's earliest images (pls. 65, 72, 75, 78, 83), the boundary of attention of the camera lens itself, which in turn proposes an analogy with the eye.

Emmet's father and namesake was a Christian fundamentalist preacher in Danville, Virginia. As Emmet recalls, his parents envisioned him becoming a "stereoscopic repetition" of his father—a future he found unimaginable. The care and example of his mother, a thoughtful Quaker, made a profound difference in opening Emmet's life to other possibilities, as did finding a way to turn his college education quietly toward art. "I think of that period of my life as simply treading very softly around the edges," he says. As a young man he was welcomed into the clan of his wife, Edith, a union that brought him many sisters and aunts and a matriarch. This chosen family became his collective muse (pls. 1, 3, 8, 12, 21, 24, 31) and the center of the world in which he and Edith raised their sons, Elijah and Isaac. Emmet has often quoted a valued mentor, Frederick Sommer: "Honor father and mother and leave home." The quicksilver example of Sommer's art, flowing out of one style, one mode of inquiry, into another, has proved perhaps the nearest thing to a template for Emmet's life in photography.

When, three decades after his father, Elijah Gowin photographed his own ephemeral constructions amid the gardens and porches of the family's Danville houses (pls. 20, 42), he did so as one born to the place. Elijah grew up first primarily in his birth state, Ohio, and later in Newtown, Pennsylvania, but he speaks of Danville as an ancestral seat to which he remained attached by emotion and annual family returns, not to mention by the art his father made there, in which he figured along with his mother and brother.

Today, when asked what his work has in common with his father's, Elijah answers: "doing what you're not supposed to do." In Emmet's constant technical rule-bending (those early round images, for example, were made by outfitting an 8x10-inch camera with the lens for a 4x5), Elijah recognizes a gleeful instinct for flipping orthodoxy creatively on its head to

see what treasures it will surrender. As a young artist in the 1990s, Elijah was unavoidably conscious of photography's digital future "knocking at the door." Whatever the nature of the new, impending orthodoxy, it was not going to be the photography he had known all his life. He says he heard it asking: "How will you be transformed?" One answer is delivered in the color photographs in his series Watering (2005) and Of Falling and Floating (2006–09) (pls. 23, 28). Though products of digital combination and editing, they have their beginnings in old snapshots by others that Elijah found online, images "raw and slightly awkward," unmoored from their original motives and seeming to illustrate the rituals of a vanished age. He reached still further back toward photography's point of origin with Into the Sun (2009) (pls. 44, 49, 66,70). The series title identifies the perspective of the camera: gazing at the source of all earthly light and, in so doing, coming to the end of pictorial description.

It was such existential themes—life and death in the image, and of the image—that brought Osamu James Nakagawa to the idea for *A Shared Elegy*. The family based facet of his work that Nakagawa reveals here grew out of changes that happened to befall his family all at once. "I am a stranger in all the places my family could call 'home,'" Nakagawa has explained. Though born in New York, he was raised in his parents' native Tokyo. He was fifteen when his business-executive father was assigned to Houston, Texas, and the family returned to the United States. For a year after college Nakagawa lived in Tokyo and worked for Takayuki Ogawa, the photographer he fondly calls his mother's "hippie" younger brother. While he was there, his uncle urged him not to end up in commercial practice, and Nakagawa further decided not to base his adult life in Japan.

He was living in Houston in 1998 when that city hosted *Beyond the Mirror*, an exhibition of his uncle's photographs that poetically chronicled Ogawa's vulnerability in the face of a severe health crisis (pl. 17). It was the first in a chain of events that deeply affected Nakagawa: in the space of a few months, his father was diagnosed with cancer, his wife became pregnant, and a new teaching position required

moving his young family north to Bloomington, Indiana. On the second day of his new job, his father died. Nakagawa's photography had never before been driven by diaristic motives, but now he found himself feeling an urgent need to "preserve and construct memory" by creating images that would contain and respond to the cascade of changes brought by cancer treatment and death, pregnancy and birth, geographic displacement, and—what has proven a longer-term subject—the growth of a child.

On the day after the memorial service Nakagawa photographed his wife and daughter posing with a framed portrait of his father (pl. 2)—a manifestly "constructed" memory not different in kind from those enacted and preserved in many family albums. Back in Bloomington, during the severe midwestern winter that followed, he soaked his father's business suit and photographed it frozen, suspended in bare tree branches overhead (pl. 30). It marked a shift toward ritual in his work: rituals that serve both to reflect on change and to produce a new kind of image. Nakagawa embedded a photograph of his father's hands in a block of ice, which he then split in half (pl. 27). Since that pivotal year of change, he has continued to build on this intimate yet theatrical tradition in his work, notably in images of his mother living in residential care in Tokyo (pls. 11, 37, 47, 61).

Artists require access to two states that are distinct from one another but not necessarily opposed. On the one hand, an artist needs firm connection—to the times, peers and family, a movement, an attuned audience, a medium or idiom, a subject, or many of these at once. On the other hand, an artist needs the confidence that is born of independence, wherein each choice, from the lens on one's camera to the continent one calls home, can be seen as reflecting a personal decision. The artist must find both a form of connection that will sustain art and the tools of independence that will provide enough room to evolve. The luckiest artists find the two conditions together in the circumstances of their domestic life. An artist who feels at once embraced and liberated has the chance to make art that models the conditions that allow all ideas, feelings, and motives to be shared.

# ELEGIES IN HARMONY

Yoshiko Suzuki

An elegy is a melancholy poem or lament that mourns the death of a friend and reminds us of the evanescence of this world. Inspired by the death of a loved one, an elegy expresses the poet's view of life and death, the meaning of life, and an acceptance of death.

*A Shared Elegy* features the work of four photographers: Elijah Gowin, Emmet Gowin, Osamu James Nakagawa, and Takayuki Ogawa. It uniquely interweaves their individual works in a single narrative as though the four were each a lead vocalist singing intermingled melodies to create a unified harmony. When we look at their photographs as a series, richly detailed information that cannot be expressed in words flows into viewers' consciousness. For a time, we leave the world of words to explore the sea of emotions unleashed by these photographs.

The book's sequence begins with Emmet Gowin's *Edith and Rennie Booher, Danville, Virginia* (pl. 1), an image of the photographer's wife, Edith, and her grandmother, Rennie. Grandmother and granddaughter, separated by a generation, sit side by side. In their physical and facial resemblances we sense their familial ties. This photograph implies the existence of a continuous family line, and the stillness that saturates the entire image gives it an eternal quality. It is as if these women, illuminated by gentle, natural light, have long been in that spot and will long remain there. The tranquil tone of this photograph colors all of the work in this publication.

Osamu James Nakagawa's *Kai, Ninomiya, Japan* (pl. 2) implies that life is passed on with the birth and death of family members. Nakagawa's wife, Tomoko, his infant daughter, Hikari, and a memorial photograph of his father are arranged in the center of the picture plane. Behind them are crashing waves. The sea suggests the birth of life and is also a place of purity. It separates the world in which the remaining family members live from the distant shore where his father has departed. Tomoko's sad expression, the cloudy sky, and the leaden coloring of the photograph as a whole reflect Nakagawa's sorrow at the death of his father. The portrait of his father, however, seems poised to speak, while his gaze and that of the cherubic Hikari face the same direction, as though

synchronized. Their shared focus is on Nakagawa behind the camera, suggesting that lives will continue to be connected across generations.

The photographs that most candidly express elements of death itself are those of Nakagawa's uncle, Takayuki Ogawa. While hospitalized with cancer, Ogawa first thought of making self-portraits from his own X-rays (see pl.18). His urgent need to capture images of himself as long as time permitted appears nostalgic, yet we also sense a lightness; a desire to accept the situation. His own impending death directed his consciousness to life. These simplified, life-sized self-portraits are photograms that combine a sense of isolation and pain with a certain thrill that turns them into comical yet aloof works. It is easy to sense an overlap with Jacques Henri Lartigue, who, fearing that his memories of his life and a childhood of almost excessive affluence would disappear or fade away, tried to record his everyday life in photographs free of grandeur or pathos.

Elijah Gowin, Emmet's son, contributes images that change in speed and tone. Like flashbacks, they float unbidden across the mind. A woman jumping in the sky, delighting in baptism, floating in midair (pls. 23, 26, 28)—these scenes, presented in distinctive hues that recall color photographs from 1970s publications, express an inner world apart from reality. They have a freedom, temporarily emancipated from reality, as though they have long nested deep within the heart and are starting to play, alone.

These photographers all work with personal subjects: parents, spouses, children, relatives, sometimes the photographer himself, or home. Snapshots of everyday life illustrate that the people we love, the people always near us, our home, and life itself are irreplaceable treasures. Yet in this book, moments blend and mingle. A specific event that occurred before one's eyes becomes, as time passes, a question: Did that really happen? Does what is photographed here really have anything to do with their life? By combining the work of these four photographers in an intermingled sequence the images blend together and empathize, forming an eternal assemblage. Blurring the boundaries between these works is one of the intentions of this book.

While straight photographic images of intimate instances form the foundation of this book, other elements, particularly recurring circular forms, perform a critical supporting role: a flower in the hand, the sphere Great-aunt Maggie is holding, the Sedan Crater at the Nevada Test Site, blood on white cloth, the track of the moth flight, the portraits of Hikari, vignetted landscapes, drops of light reflected on snow, the beautiful color of the sun, a ball made of wire, or Mount Fuji seen through a soap bubble. The final work in the sequence (pl. 83), a round path formed by trees, opening out onto the land in Ireland, leaves one with a sense of hope. The circle implies eternity, perfection, heaven, the universe. In these four photographers' works, it suggests life and death, rebirth, cycles, nature, and the soul.

This harmonic elegy of works is assembled through images of intervals of life. Each is a gleaming fragment, for each photographer thinks of death. Here are shared images that will never recur, that are irreplaceable.

PLATES

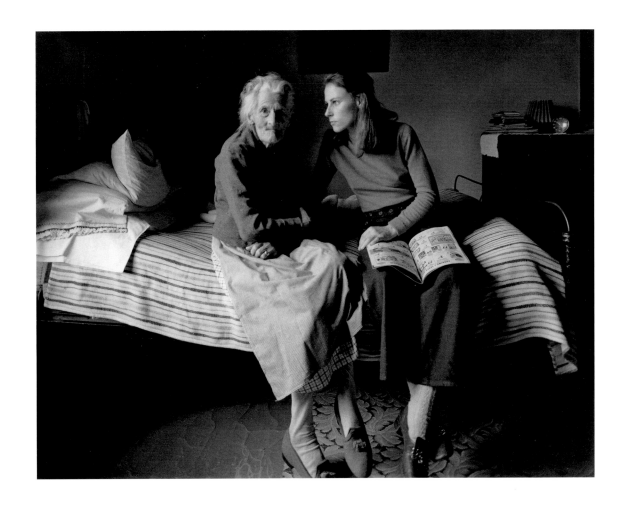

PLATE 1.   Emmet Gowin, *Edith and Rennie Booher, Danville, Virginia*, 1969

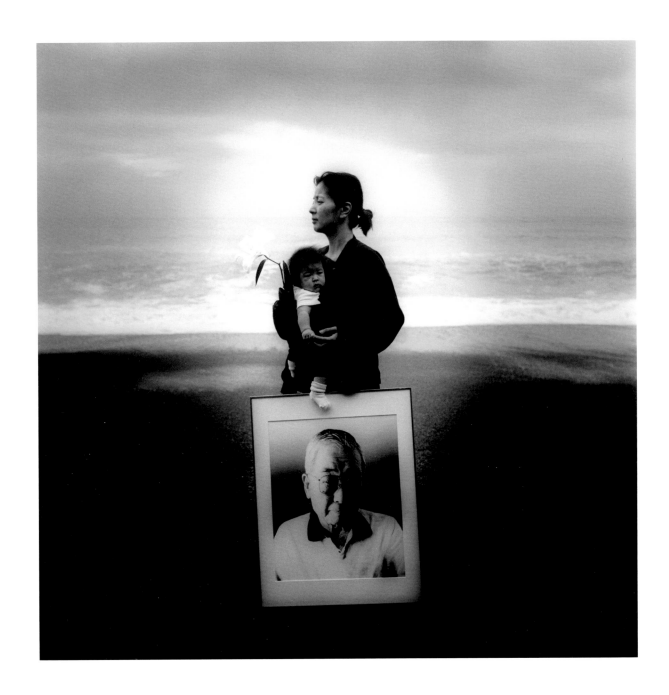

PLATE 2. Osamu James Nakagawa, *Kai, Ninomiya, Japan*, Autumn 1998

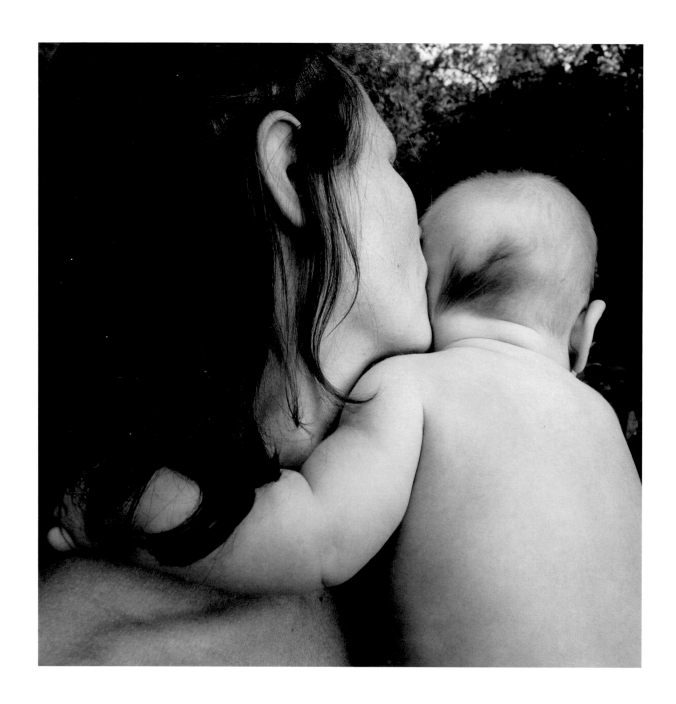

PLATE 3. Emmet Gowin, *Edith and Isaac, Newton, Pennsylvania*, 1974

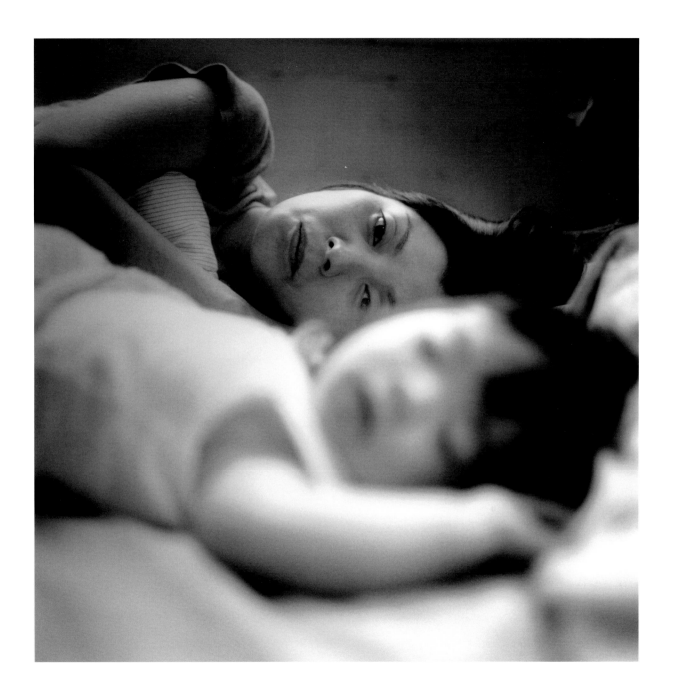

PLATE 4. Osamu James Nakagawa, *Tomoko's Gaze*, *New York*, Autumn 1999

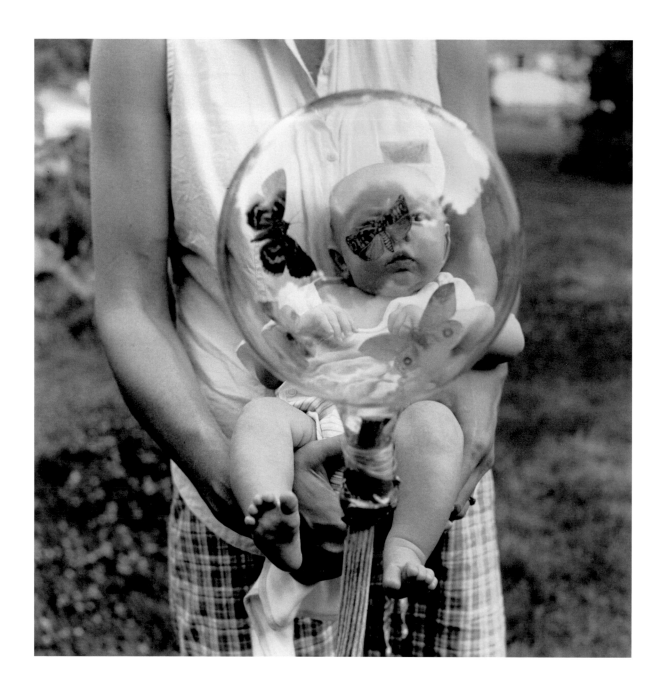

PLATE 5. Elijah Gowin, *Bubble Baby*, 2002

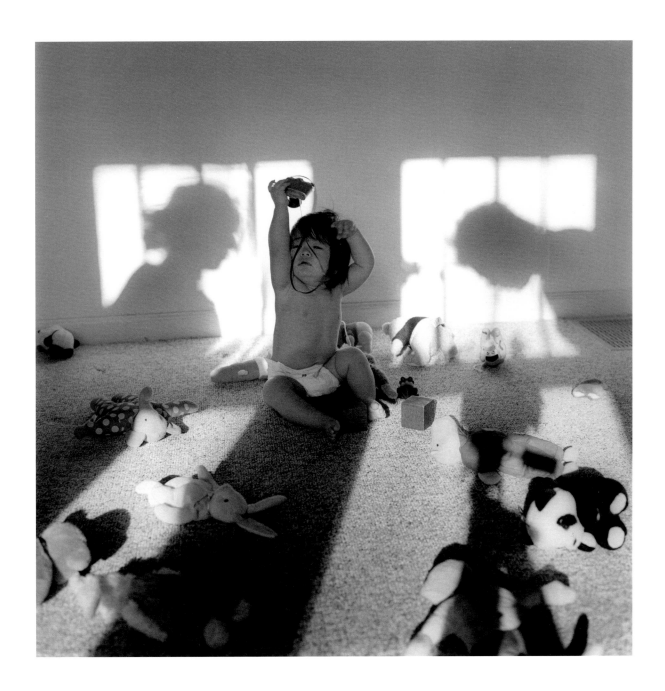

PLATE 6. Osamu James Nakagawa, *Morning Light, Bloomington, Indiana*, Spring 1999

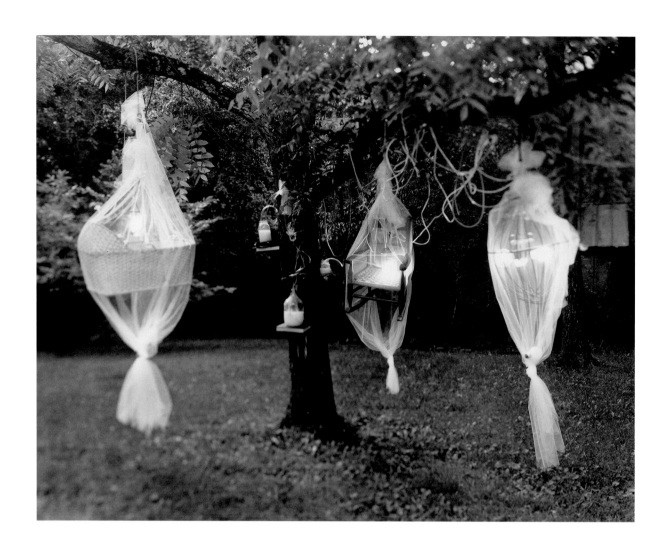

PLATE 7. Elijah Gowin, *Cocoon*, 2002

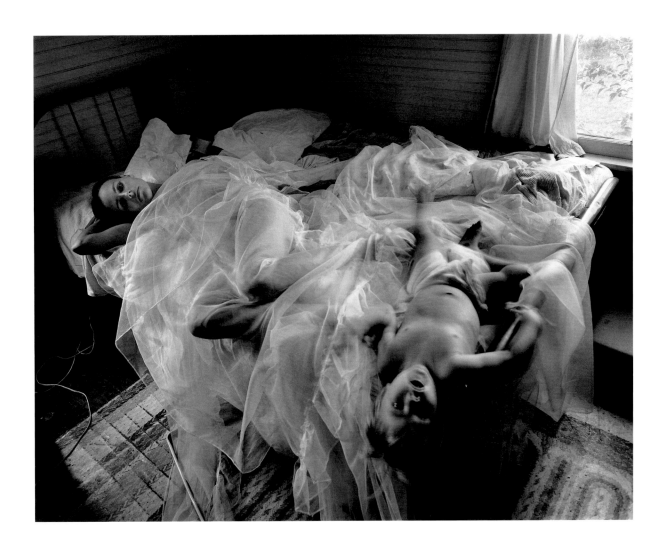

PLATE 8. Emmet Gowin, *Edith and Elijah, Danville, Virginia,* 1968

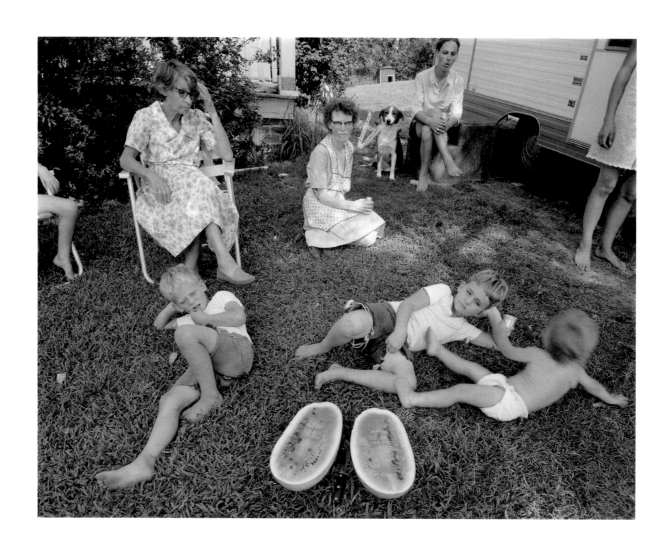

PLATE 9. Emmet Gowin, *Family, Danville, Virginia,* 1970

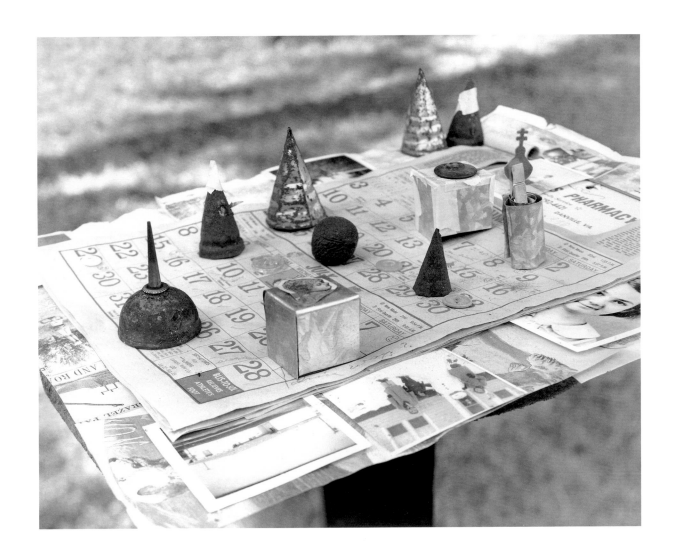

PLATE 10. Elijah Gowin, *Game*, 2001

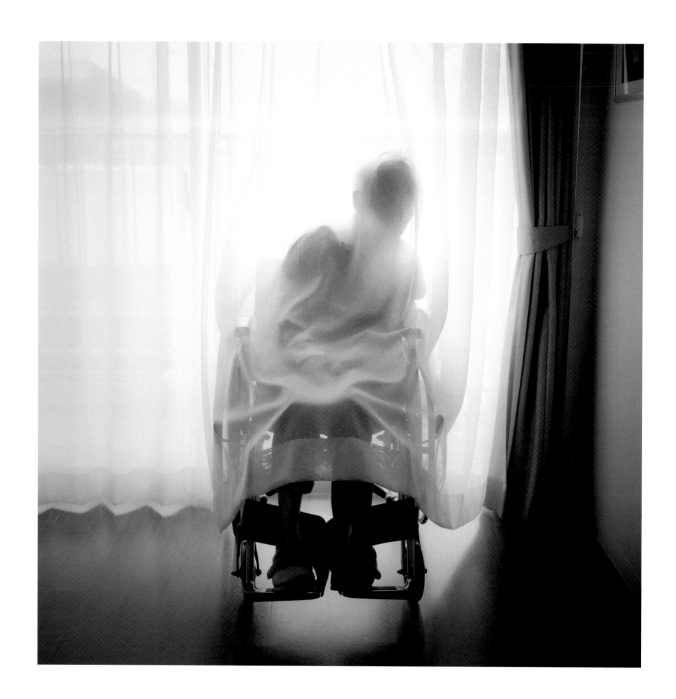

PLATE 11. Osamu James Nakagawa, *Curtain, Tokyo, Japan*, Spring 2013

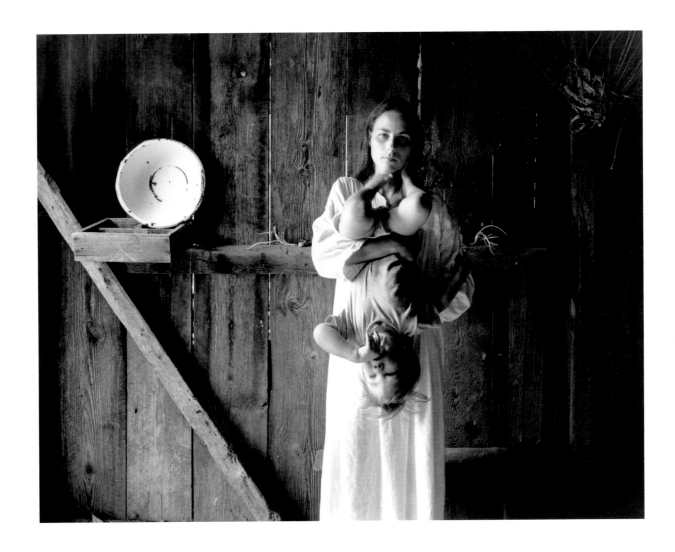

PLATE 12. Emmet Gowin, *Edith and Elijah, Danville, Virginia,* 1968

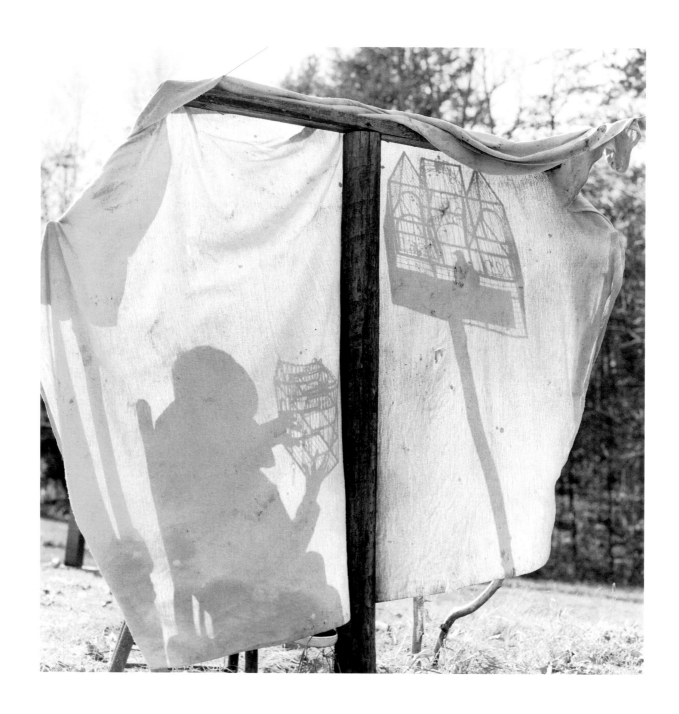

PLATE 13. Elijah Gowin, *Cage*, 1999

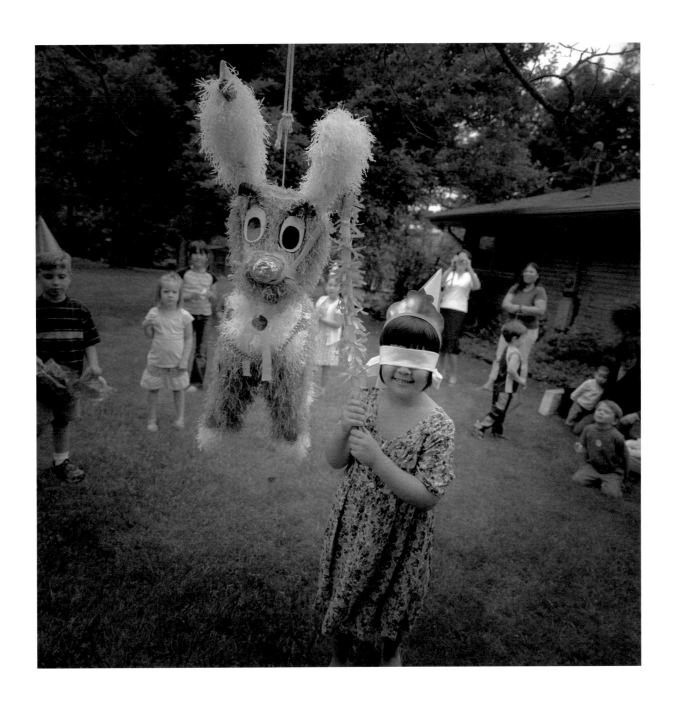

PLATE 14. Osamu James Nakagawa, *Piñata, Bloomington, Indiana,* Spring 2004

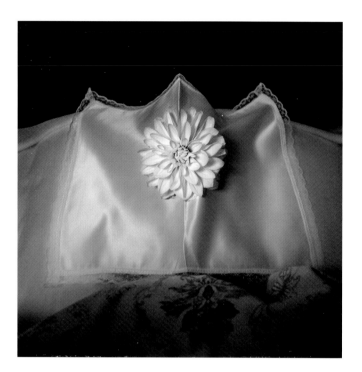

PLATE 15. Osamu James Nakagawa,
*Dahlia, Tokyo, Japan,* Spring 2013

PLATE 16. Osamu James Nakagawa,
*Contact, Tokyo, Japan,* Spring 2013

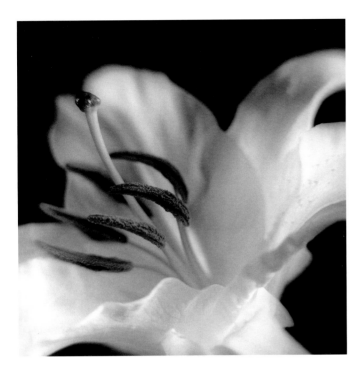 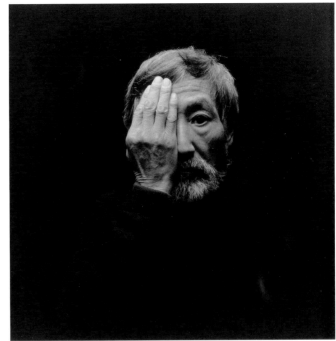

PLATE 17. Takayuki Ogawa, *Untitled 06*, 1995-97

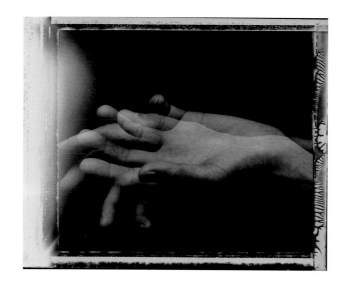
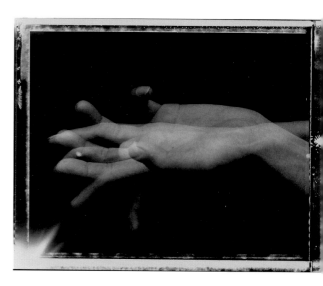

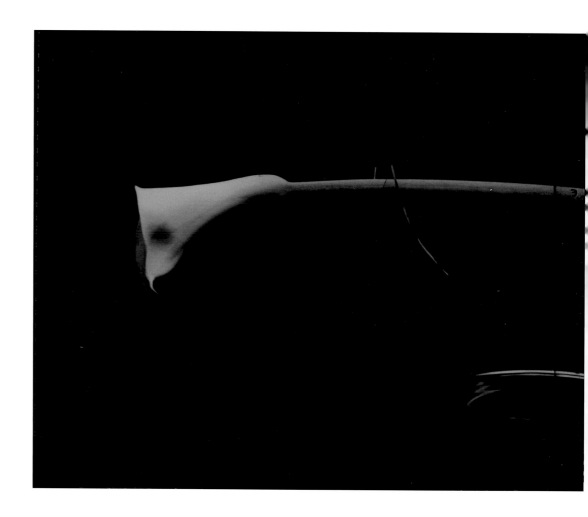

PLATE 18. Takayuki Ogawa, *Untitled 02*, 1995–97

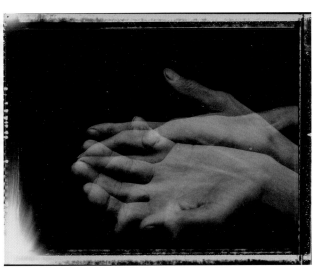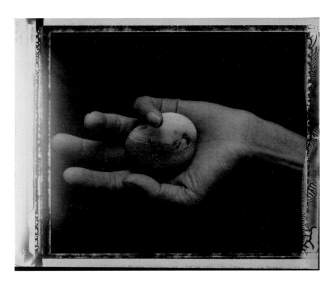

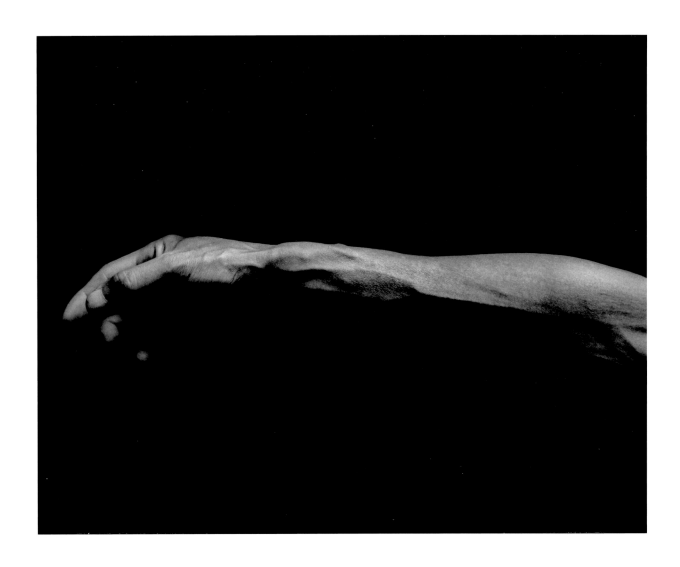

PLATE 19. Takayuki Ogawa, *Untitled 14*, 1995–97

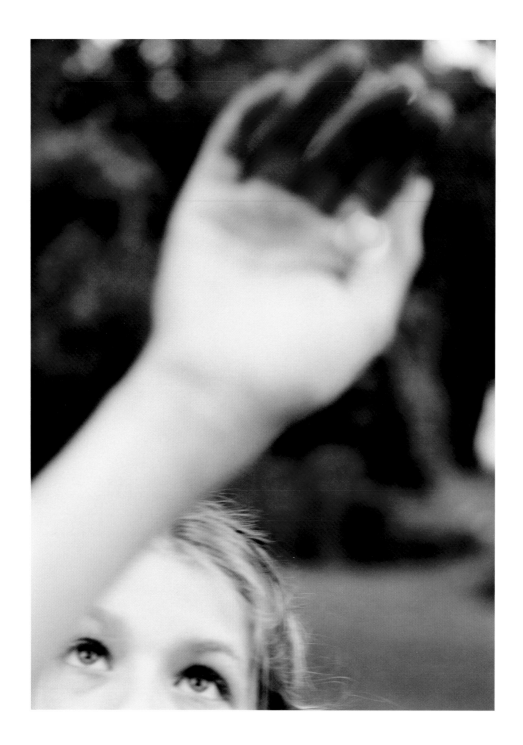

PLATE 20. Elijah Gowin, *Violet Catching Firefly, Danville, Virginia,* 2016

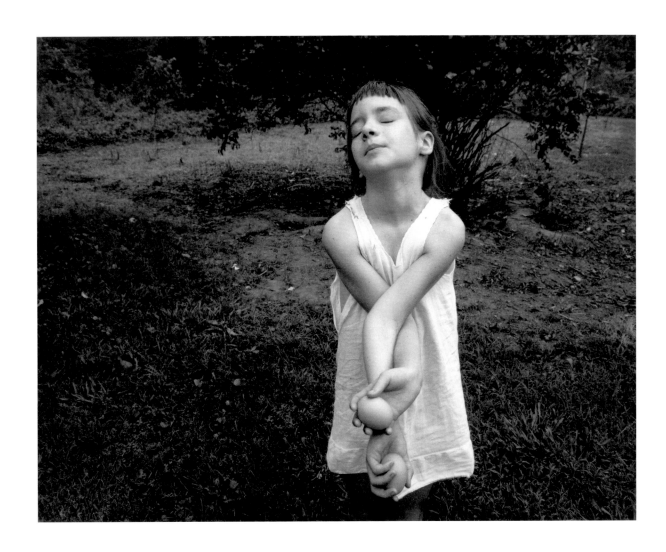

PLATE 21. Emmet Gowin, *Nancy, Danville, Virginia,* 1969

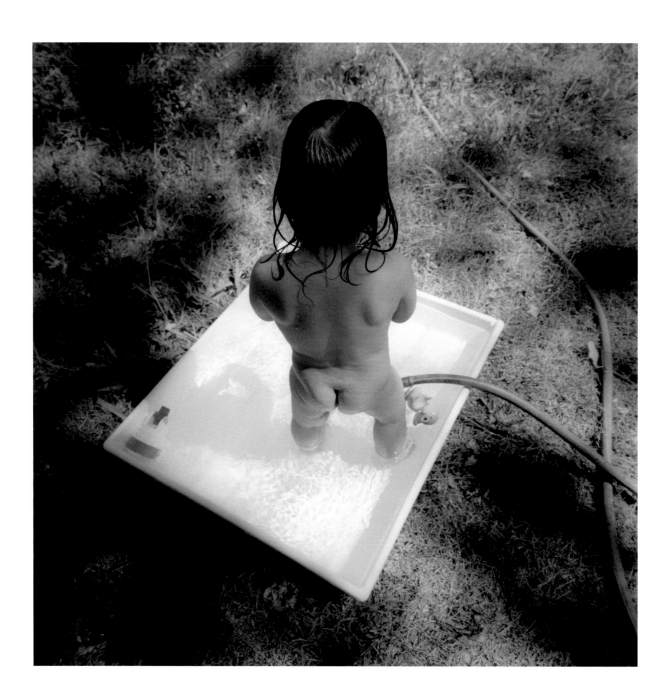

PLATE 22. Osamu James Nakagawa, *Bathing, Bloomington, Indiana*, Summer 1999

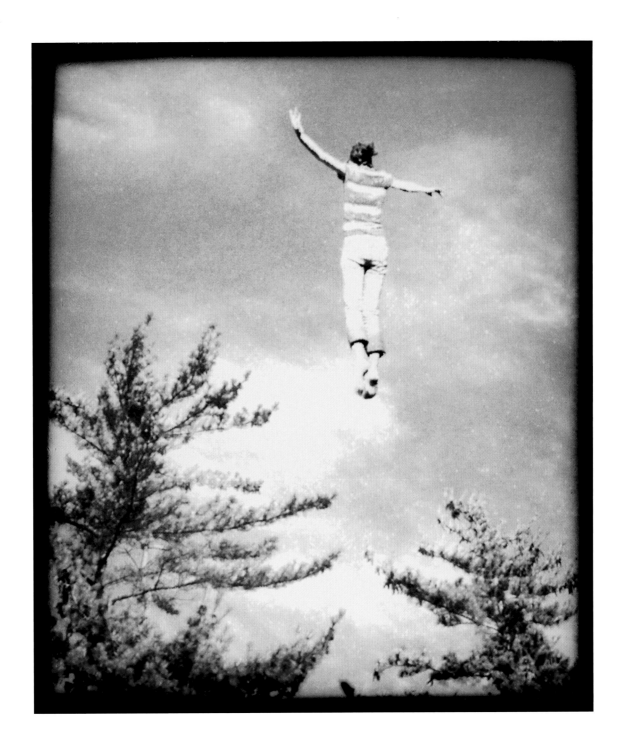

PLATE 23.  Elijah Gowin, *Falling in Trees 6, 2007*

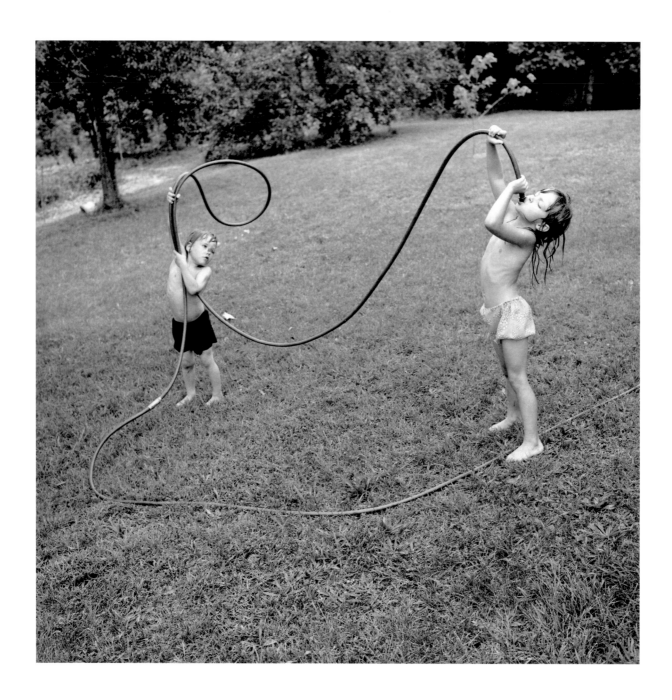

PLATE 24.  Emmet Gowin, *Elijah and Donna Jo, Danville, Virginia,* 1971

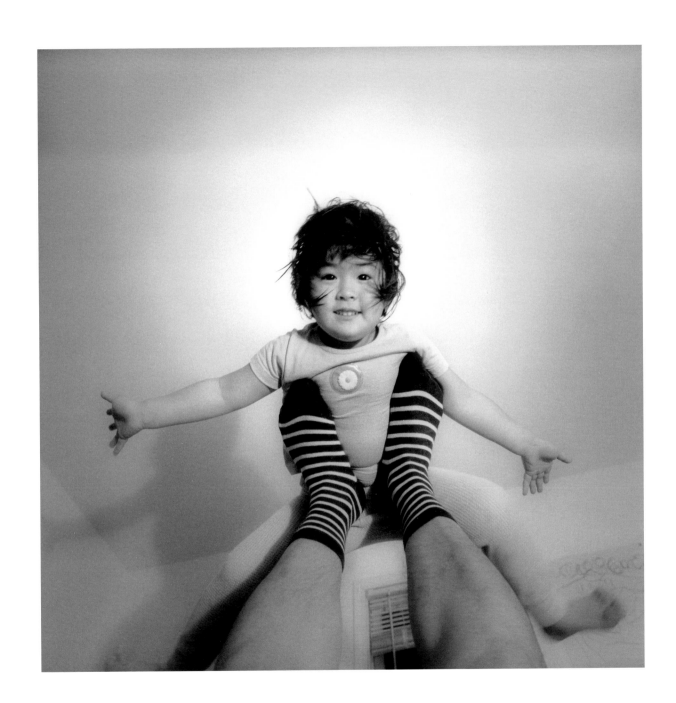

PLATE 25. Osamu James Nakagawa, *Airplane (Takai Takai), Bloomington, Indiana,* Winter 2001

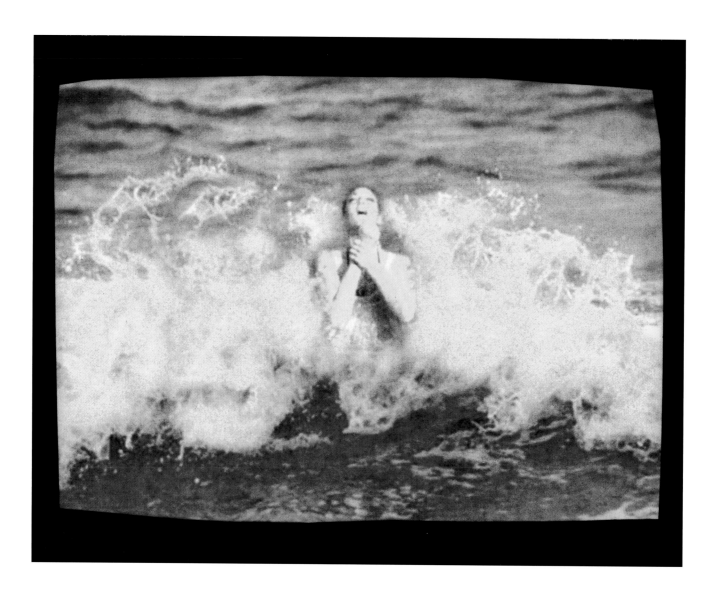

PLATE 26. Elijah Gowin, *Gasp 1*, 2005

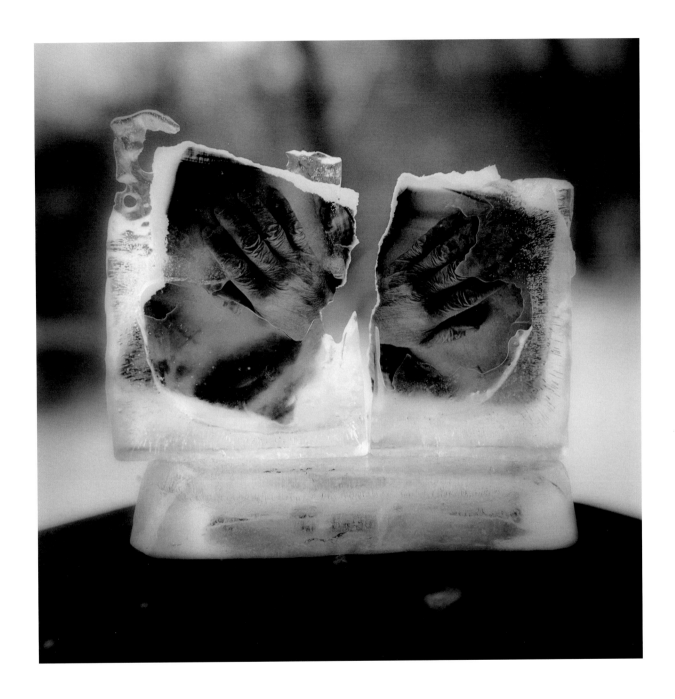

PLATE 27. Osamu James Nakagawa, *Father's Hands, Bloomington, Indiana,* Winter 1999

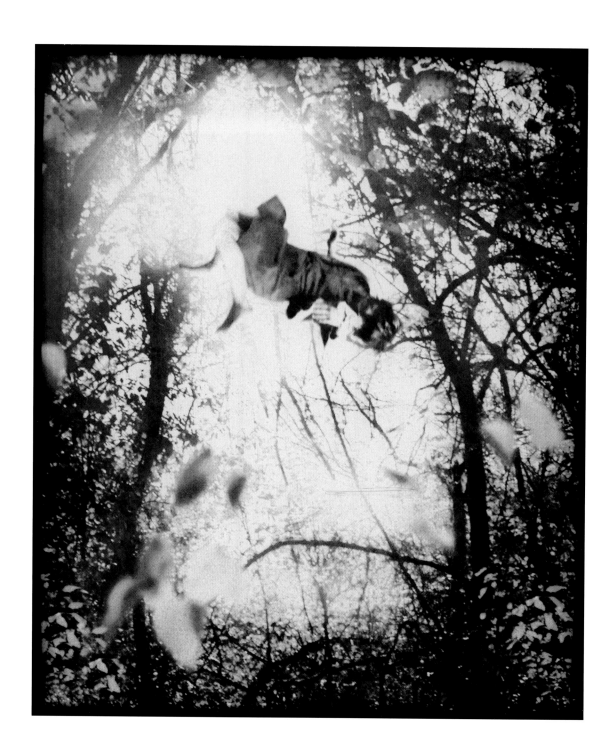

PLATE 28. Elijah Gowin, *Falling in Trees 14*, 2007

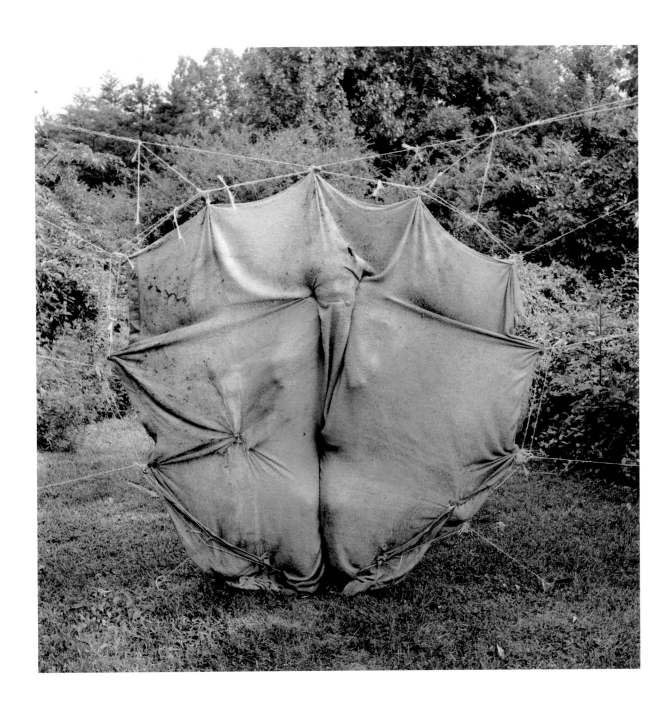

PLATE 29. Emmet Gowin, *Barry and Dwayne, Danville, Virginia*, 1971

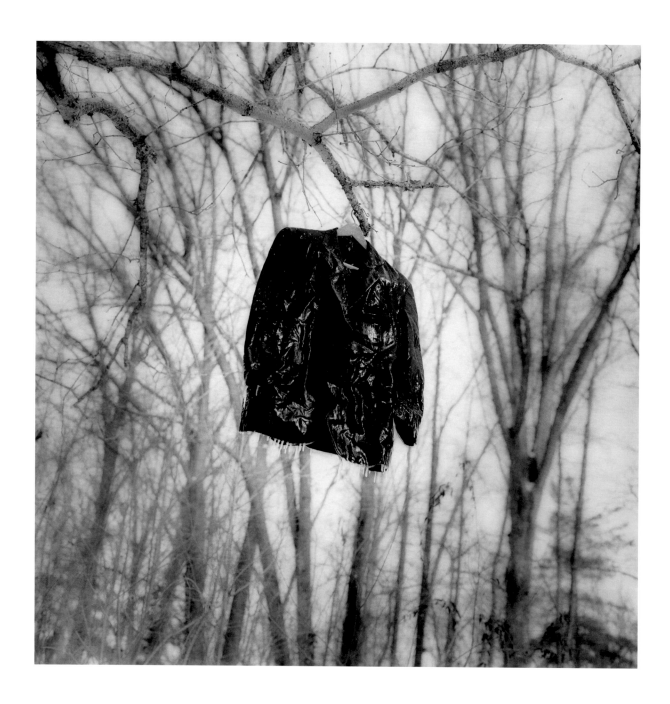

PLATE 30. Osamu James Nakagawa, *Frozen Jacket, Bloomington, Indiana*, Winter 1998

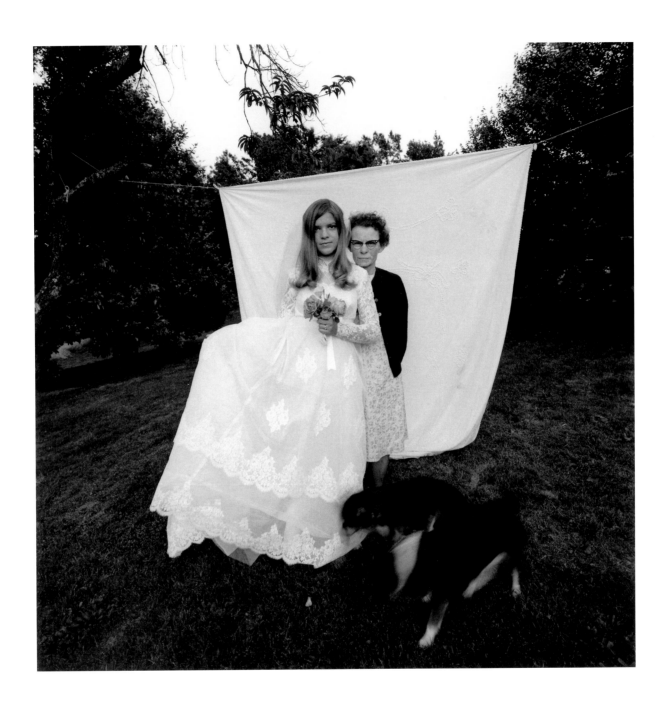

PLATE 31. Emmet Gowin, *Maggie and Darlene, Danville, Virginia,* 1971

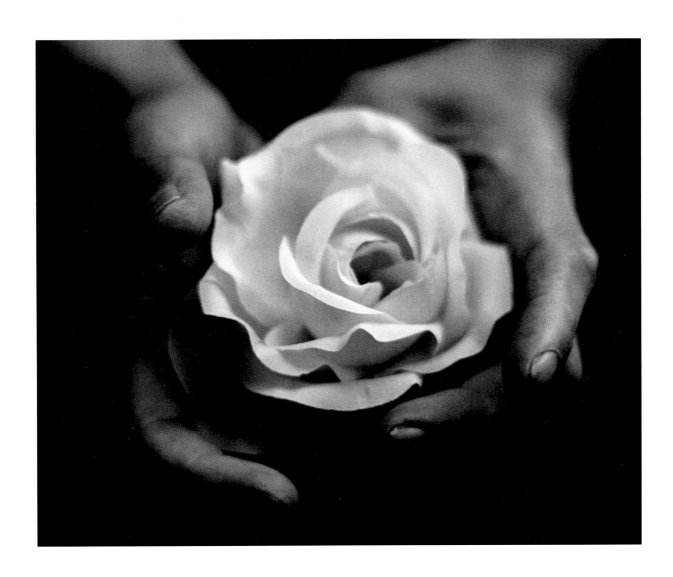

PLATE 32. Takayuki Ogawa, *Untitled 21*, 1995–97

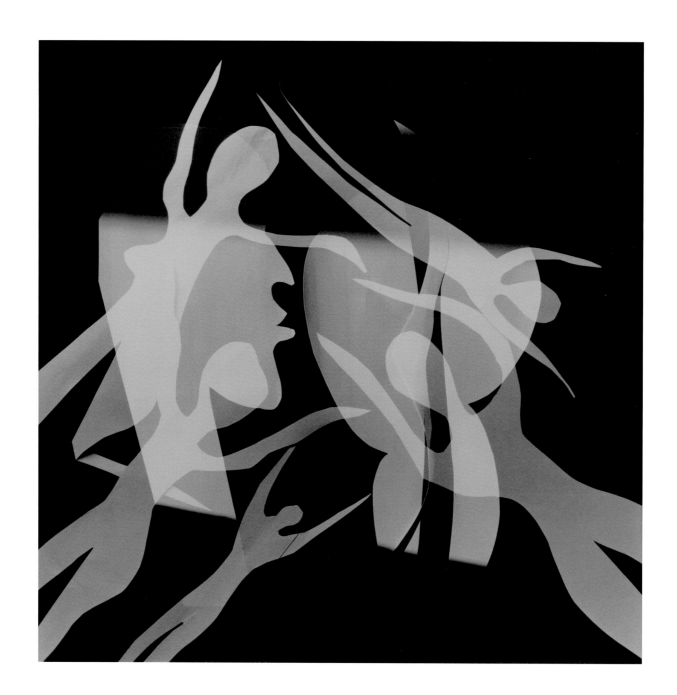

PLATE 33. Takayuki Ogawa, *Untitled 17*, 1995–97

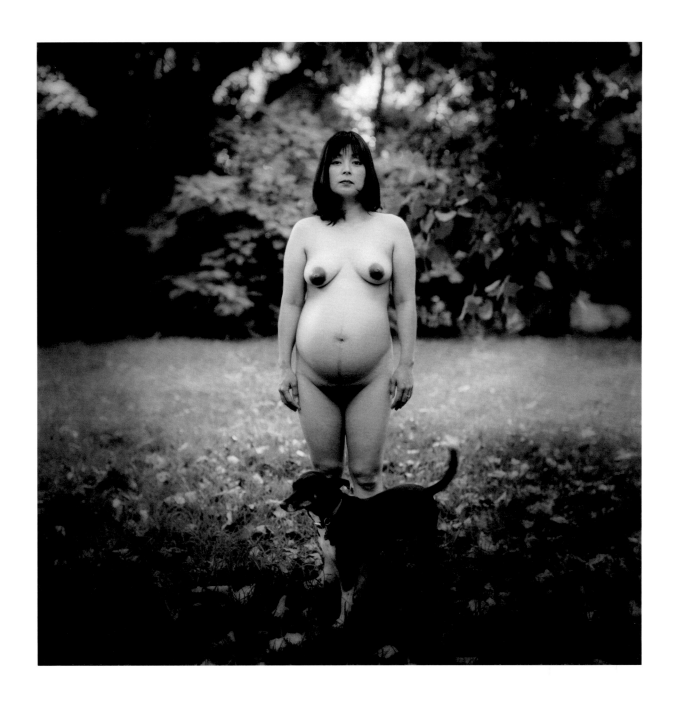

PLATE 34. Osamu James Nakagawa, *Tomoko, Houston, Texas*, Spring 1998

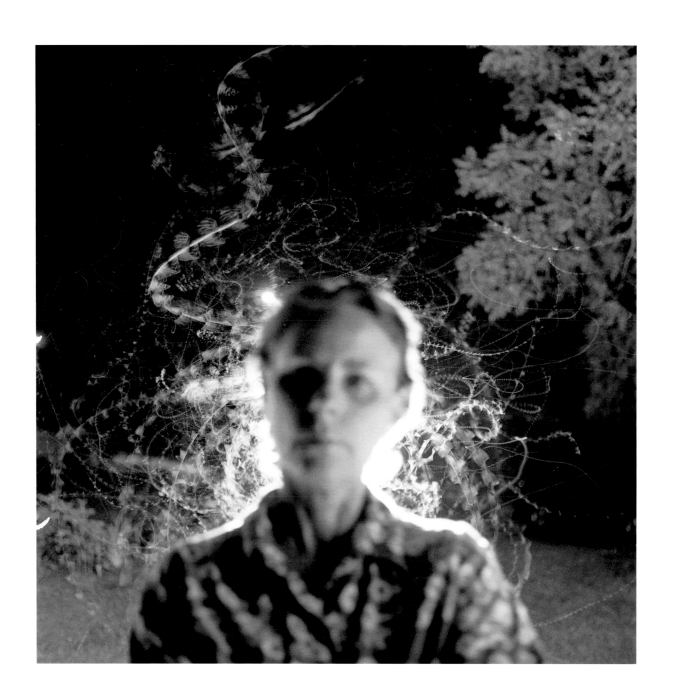

PLATE 35.  Emmet Gowin, *Edith and Moth Flight*, 2002

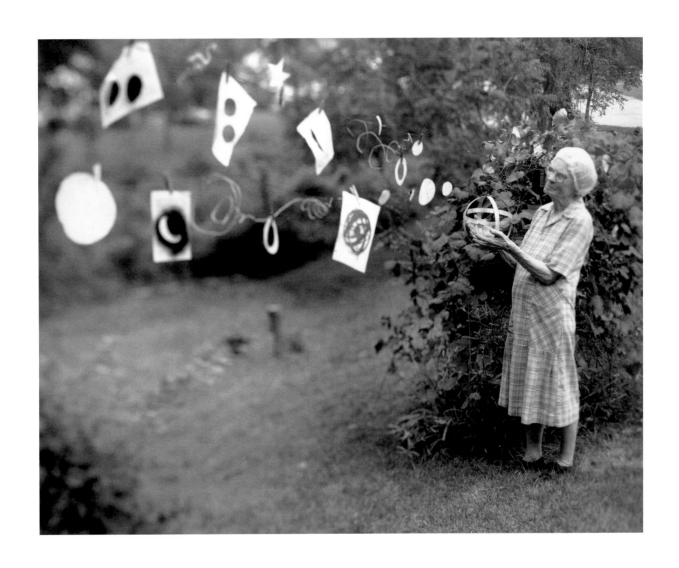

PLATE 36. Elijah Gowin, *Maggie and Orbs*, 2001

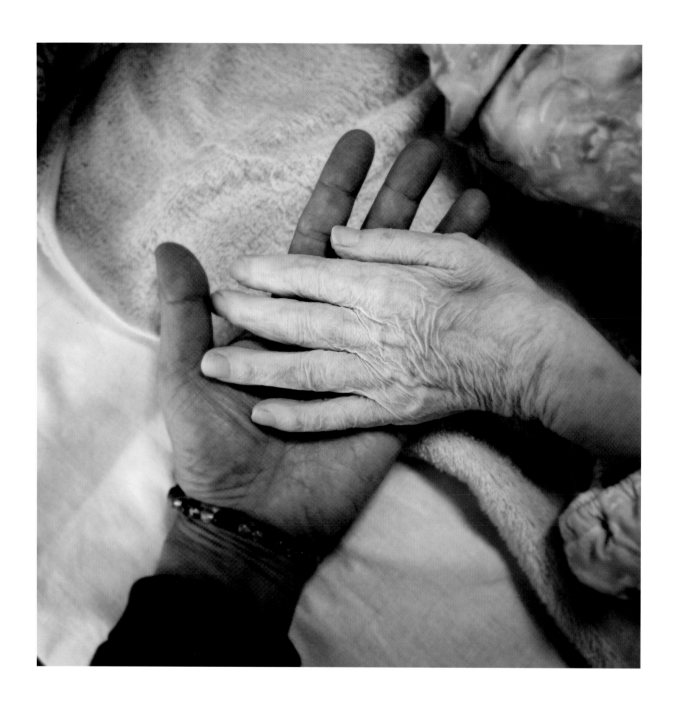

PLATE 37. Osamu James Nakagawa, *Hands, Tokyo, Japan*, Spring 2013

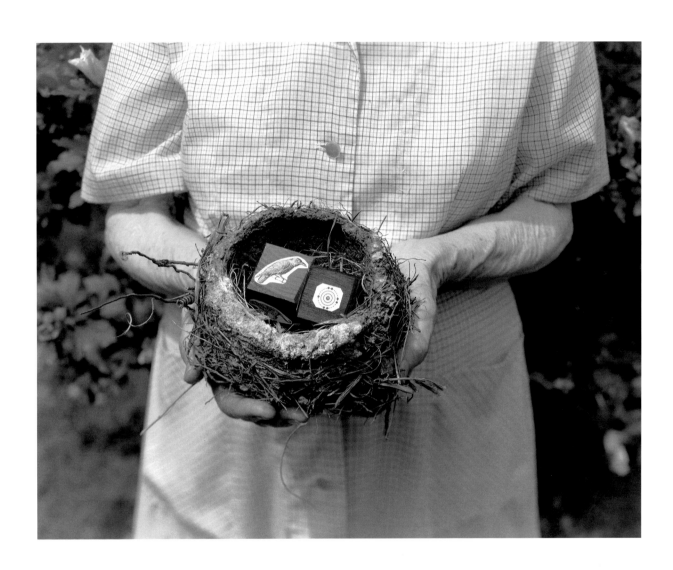

PLATE 38. Elijah Gowin, *Nest*, 2001

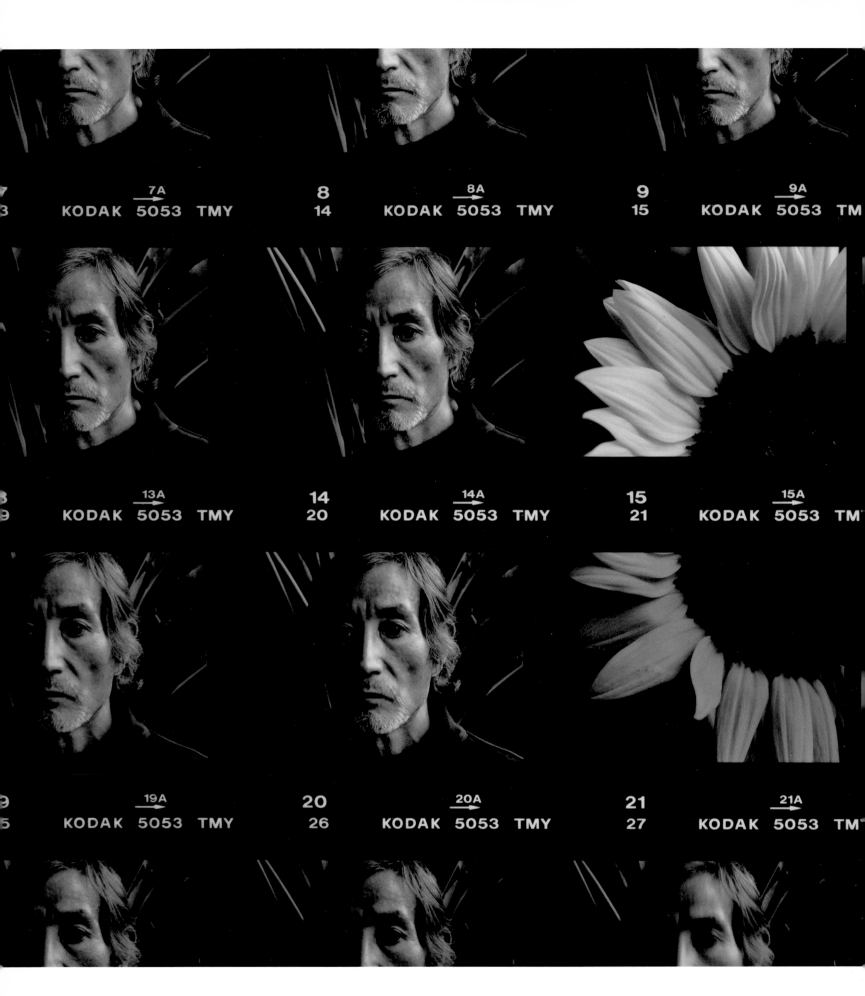

PLATE 39. Takayuki Ogawa, *Untitled 05*, 1995–97

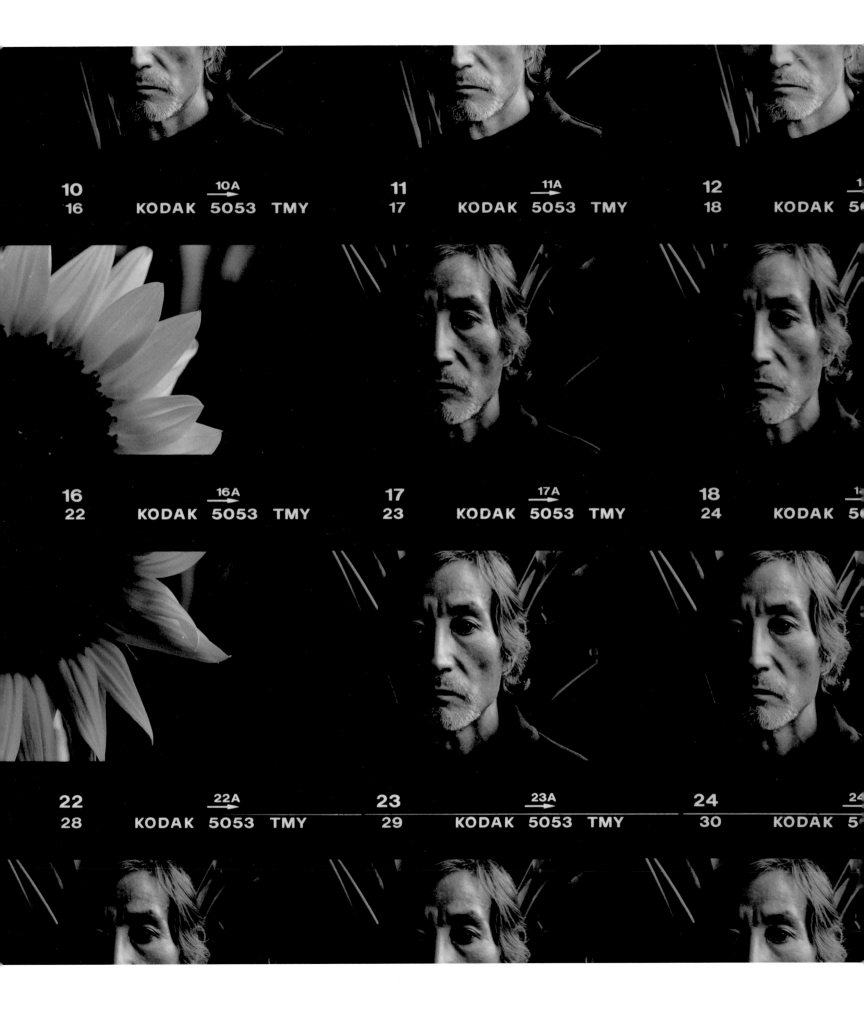

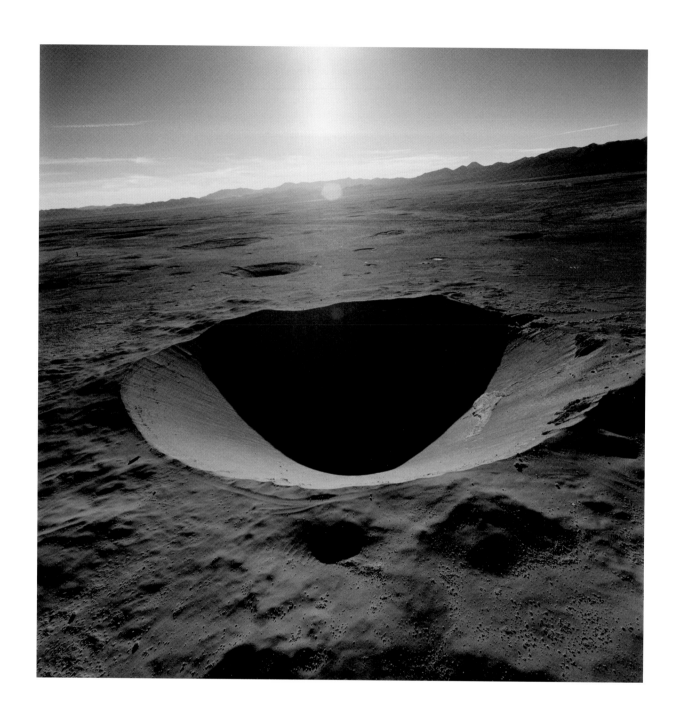

PLATE 40. Emmet Gowin, *Sedan Crater, Northern End of Yucca Flat, Nevada Test Site*, 1996

PLATE 41.  Osamu James Nakagawa, *Leaving Tokyo, Japan,* Winter 2011

PLATE 42. Elijah Gowin, *Fiona on Porch with Firefly, Danville, Virginia*, 2016

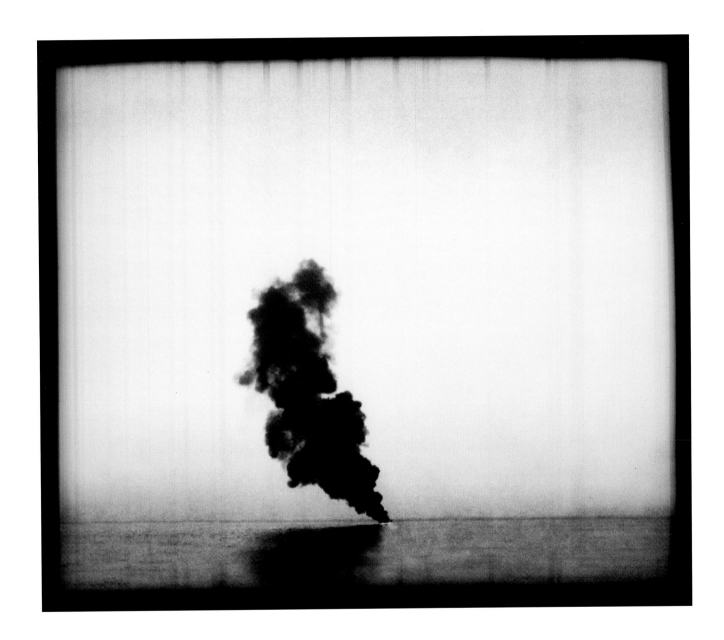

PLATE 43. Elijah Gowin, *Fire 4*, 2009

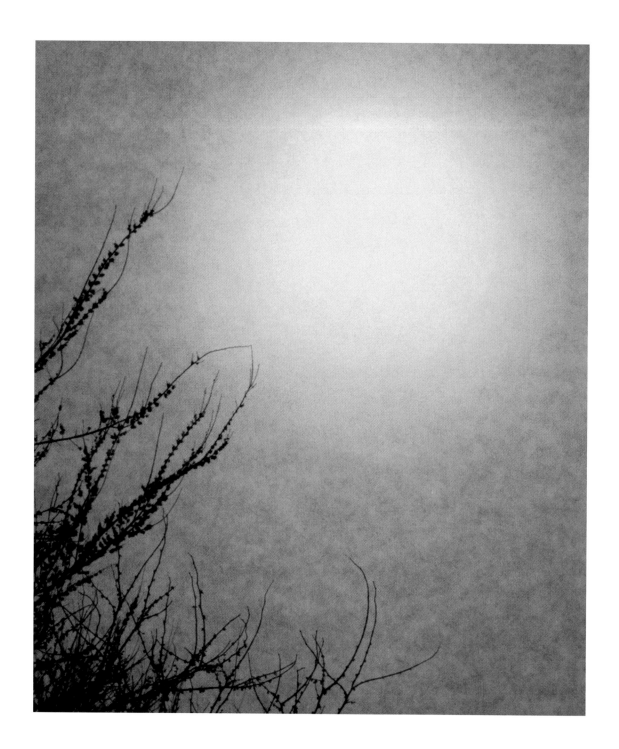

PLATE 44.  Elijah Gowin, *Into the Sun 26*, 2009

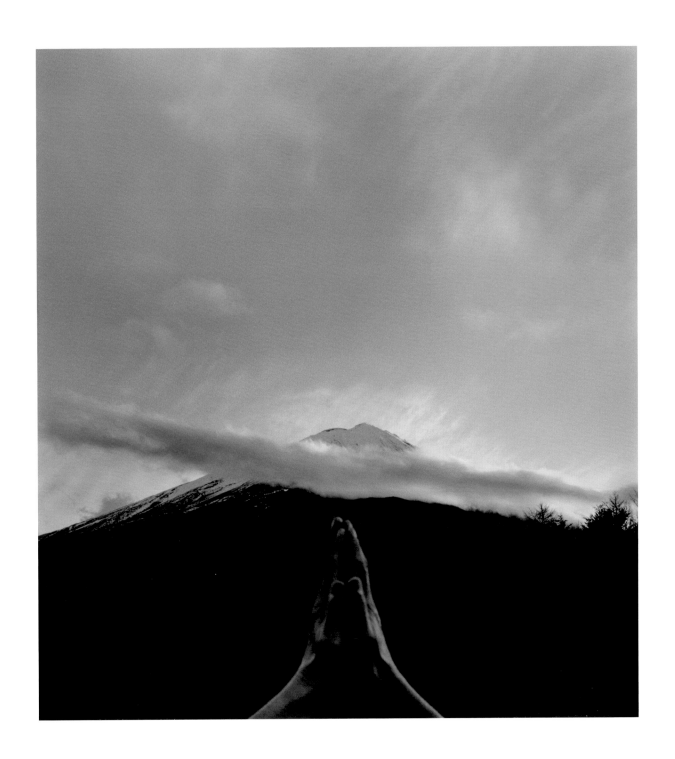

PLATE 45.  Takayuki Ogawa, *Untitled 20*, 1995–97

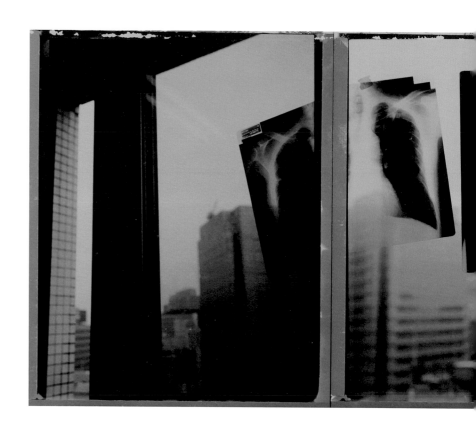

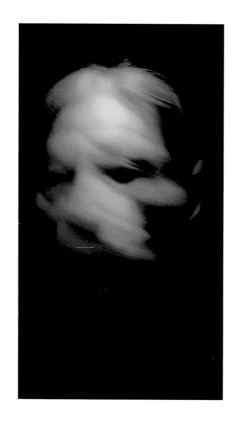

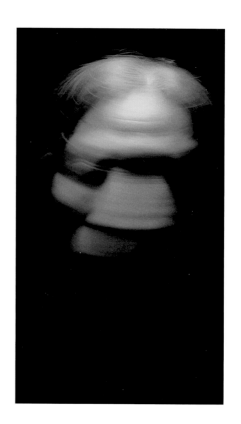

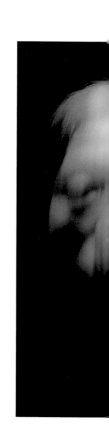

PLATE 46. Takayuki Ogawa, *Untitled 01*, 1995–97

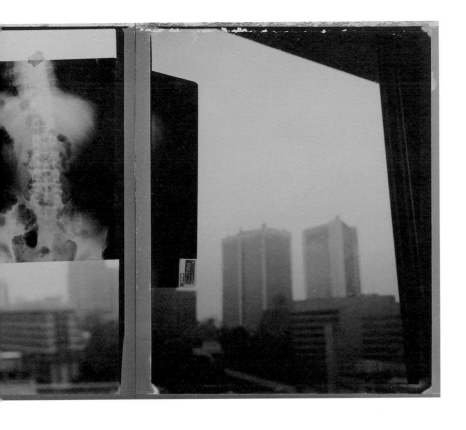
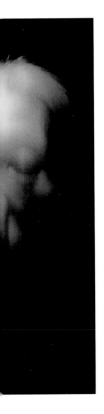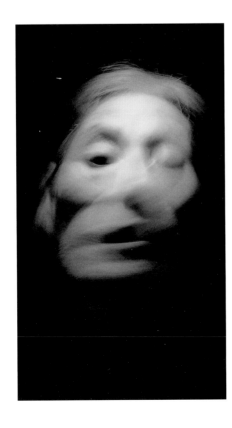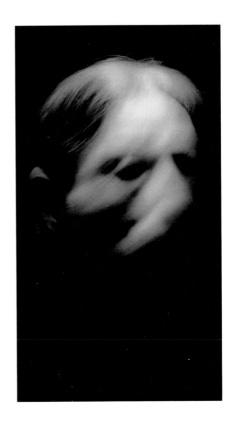

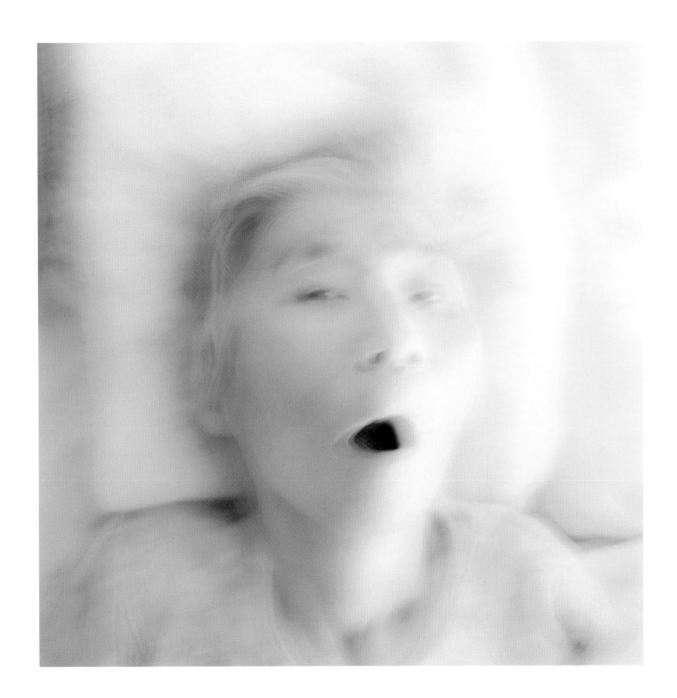

PLATE 47. Osamu James Nakagawa, *Final Conversation, Tokyo, Japan*, Spring 2013

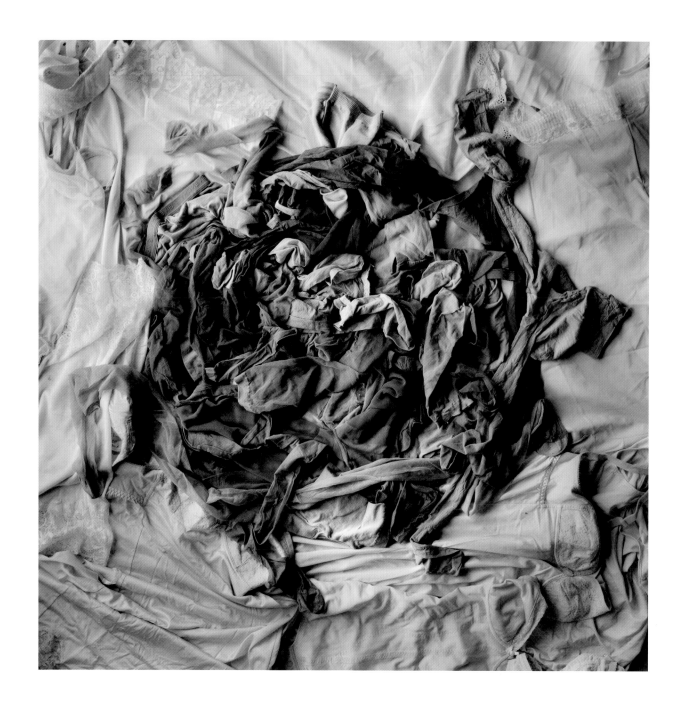

PLATE 48. Osamu James Nakagawa, *Stockings, Ninomiya, Japan*, Spring 2013

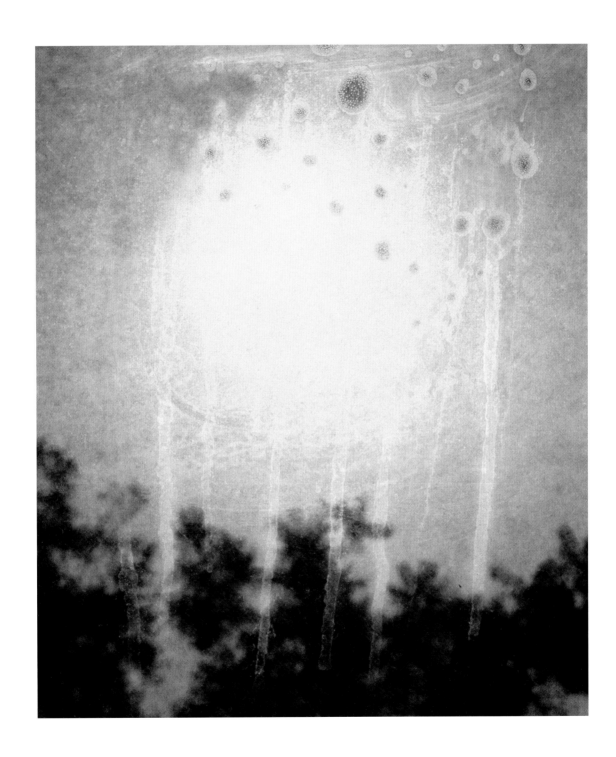

PLATE 49. Elijah Gowin, *Into the Sun 40*, 2009

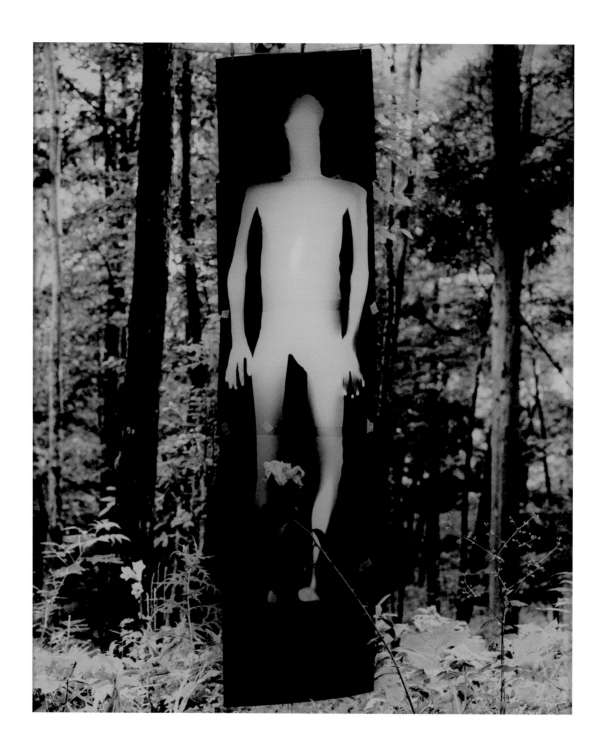

PLATE 50. Takayuki Ogawa, *Untitled 13*, 1995–97

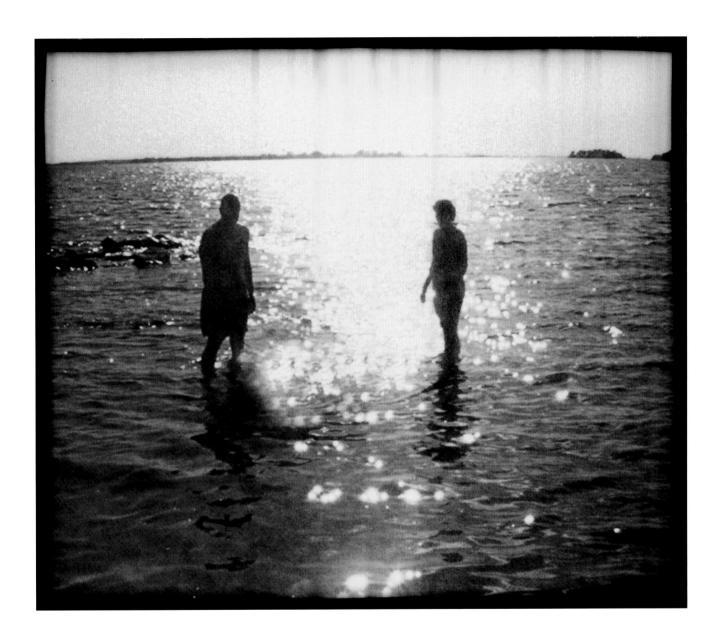

PLATE 51. Elijah Gowin, *Divide 1*, 2006

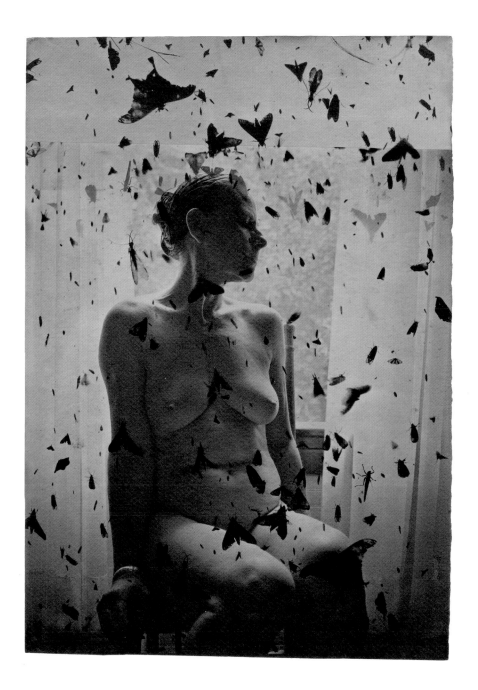

PLATE 52. Emmet Gowin, *Edith in Panama, Deep Violet*, 2005

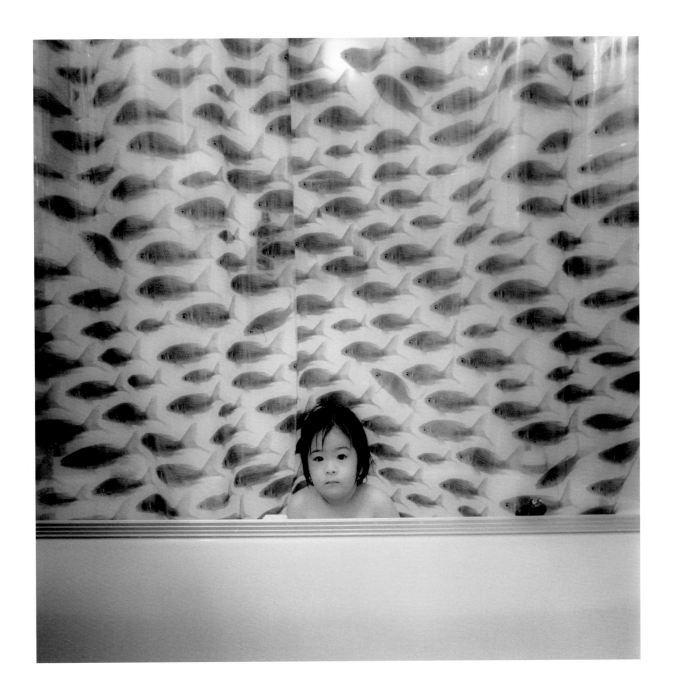

PLATE 53. Osamu James Nakagawa, *Gold Fishes, Bloomington, Indiana*, Winter 2000

PLATE 54. Takayuki Ogawa, *Untitled 18*, 1995–97

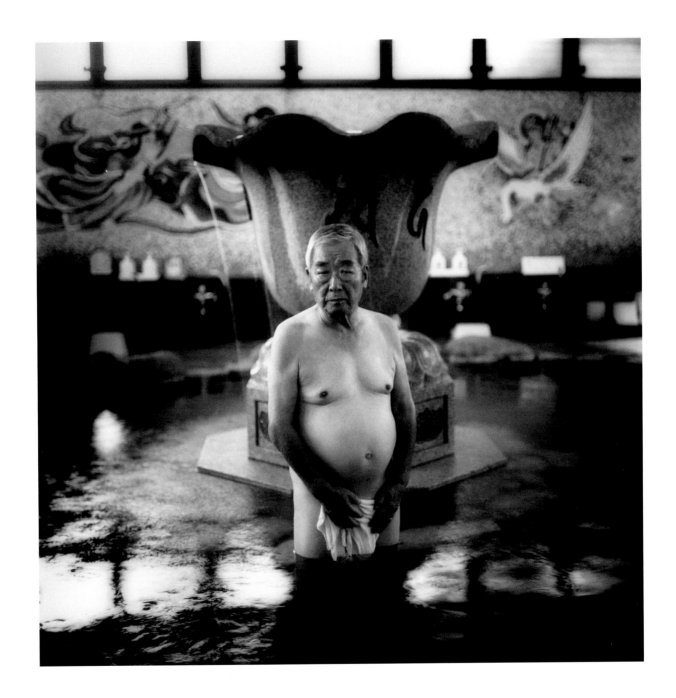

PLATE 55. Osamu James Nakagawa, *Hot Springs, Hakone, Japan*, Summer 1998

PLATE 56. Elijah Gowin, *Eye Holes*, 2001

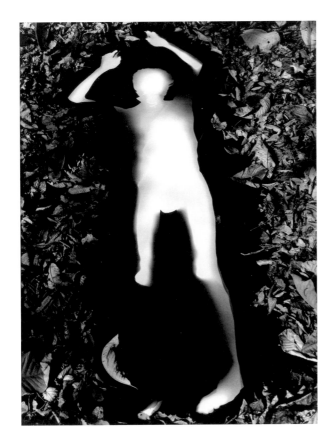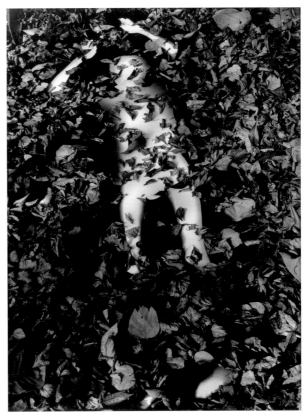

PLATE 57. Takayuki Ogawa, *Untitled 12*, 1995–97

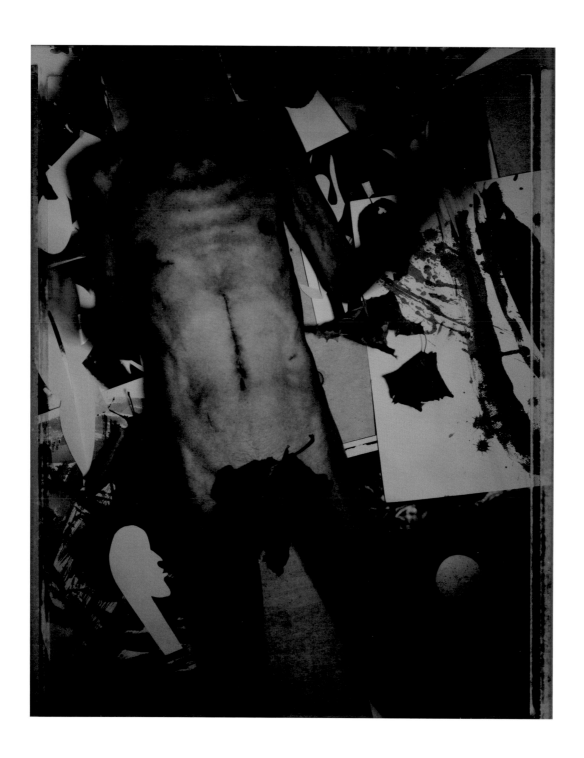

PLATE 58. Takayuki Ogawa, *Untitled 15*, 1995–97

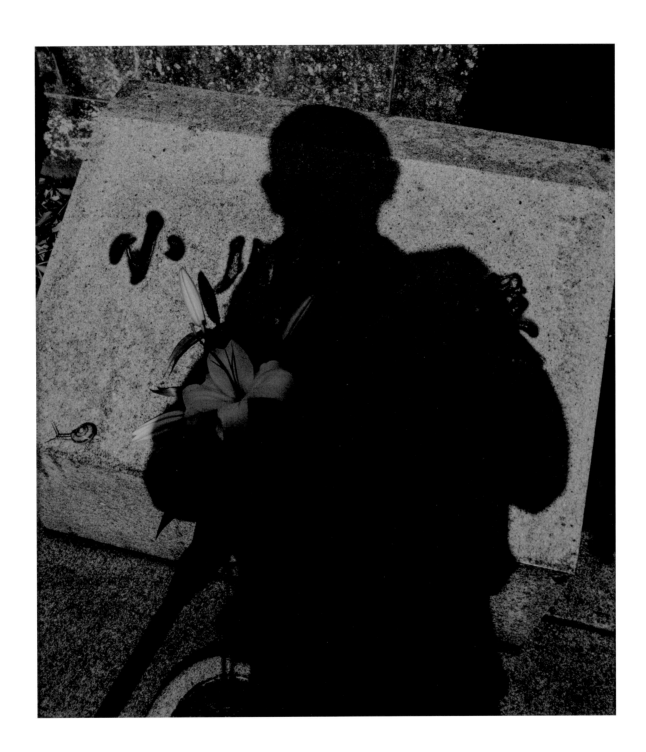

PLATE 59. Takayuki Ogawa, *Untitled 16*, 1995–97

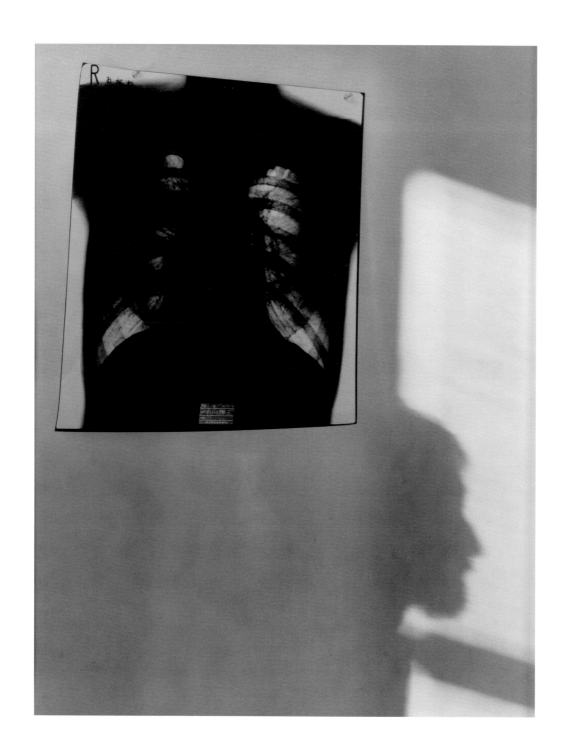

PLATE 60. Takayuki Ogawa, *Untitled 07*, 1995–97

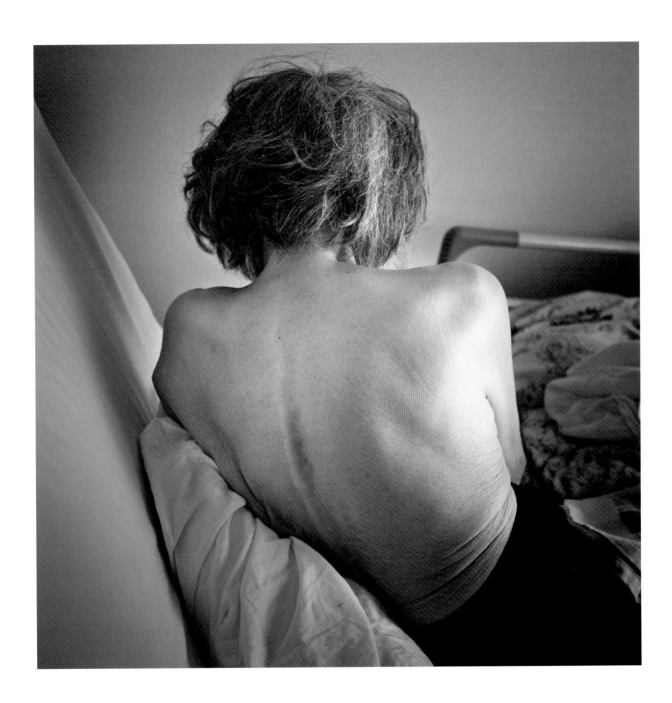

PLATE 61. Osamu James Nakagawa, *Mother's Back, Tokyo*, Summer 2010

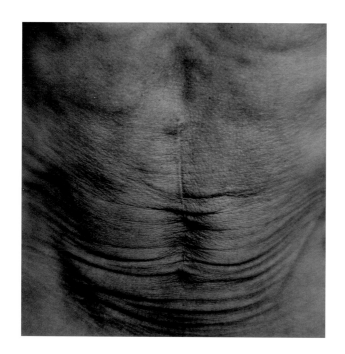 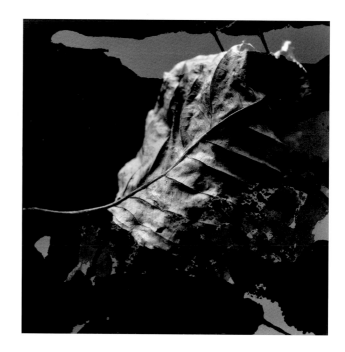

PLATE 62. Takayuki Ogawa, *Untitled 10*, 1995–97

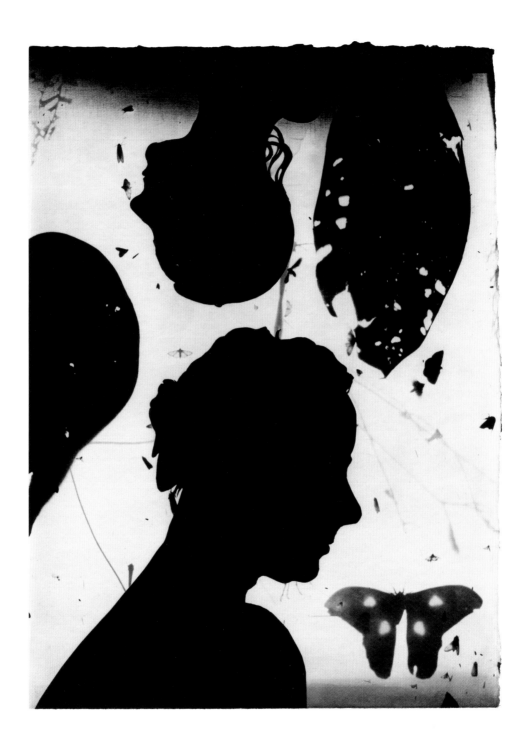

PLATE 63. Emmet Gowin, *Edith in Panama, Double Edith and Rothschildia*, 2003

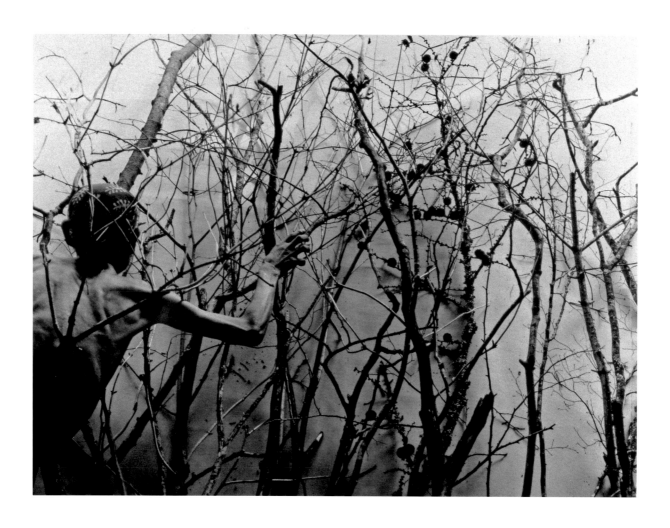

PLATE 64. Takayuki Ogawa, *Untitled 22*, 1995–97

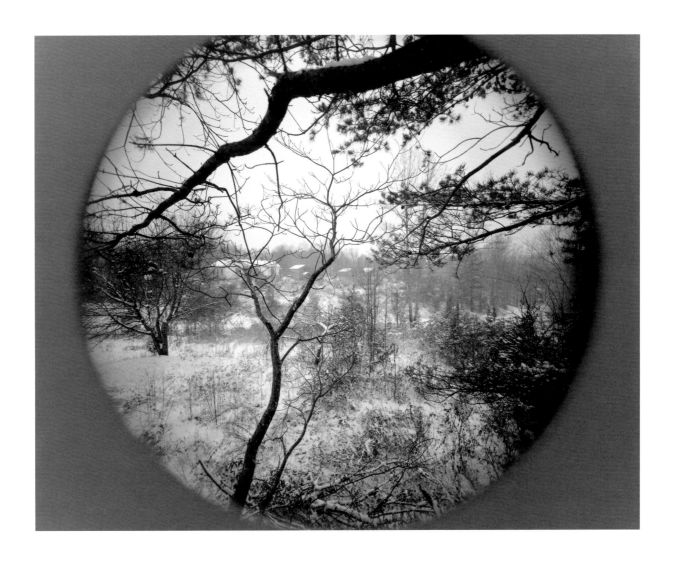

PLATE 65. Emmet Gowin, *View of Rennie Booher's House, Danville, Virginia,* 1973

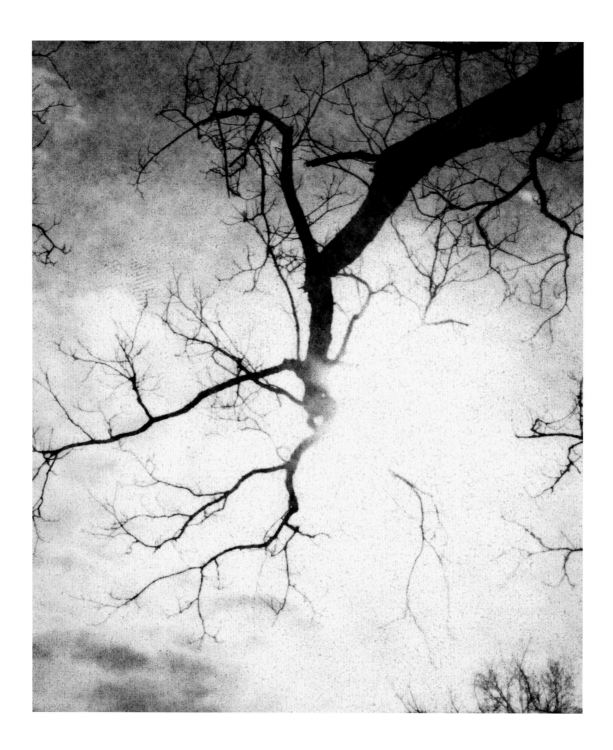

PLATE 66. Elijah Gowin, *Into the Sun 37*, 2009

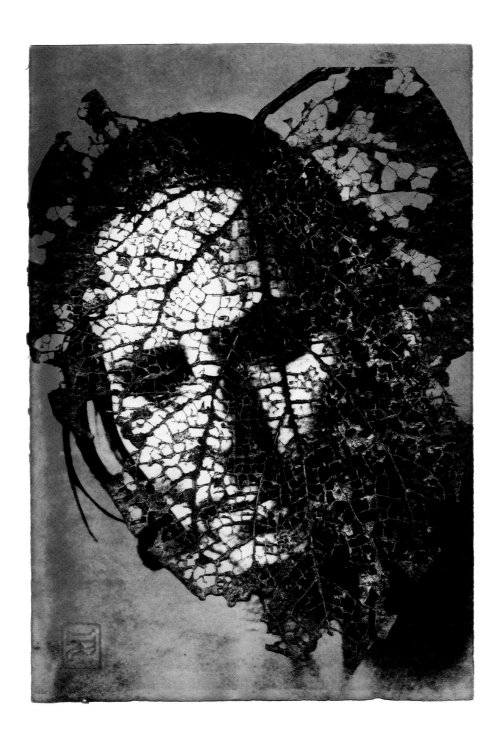

PLATE 67. Emmet Gowin, *Edith in Panama, Leaf Mask*, 2004

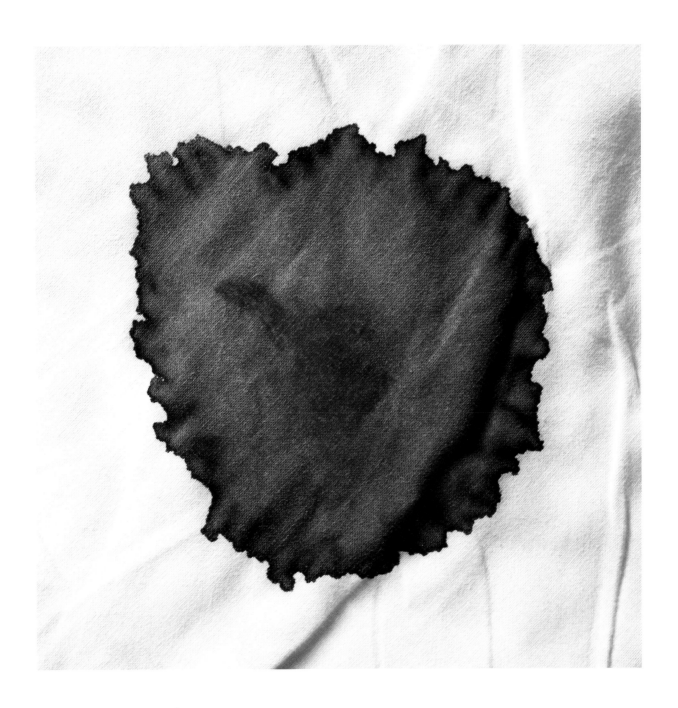

PLATE 68. Osamu James Nakagawa, *Blood, Kyoto, Japan*, Summer 2014

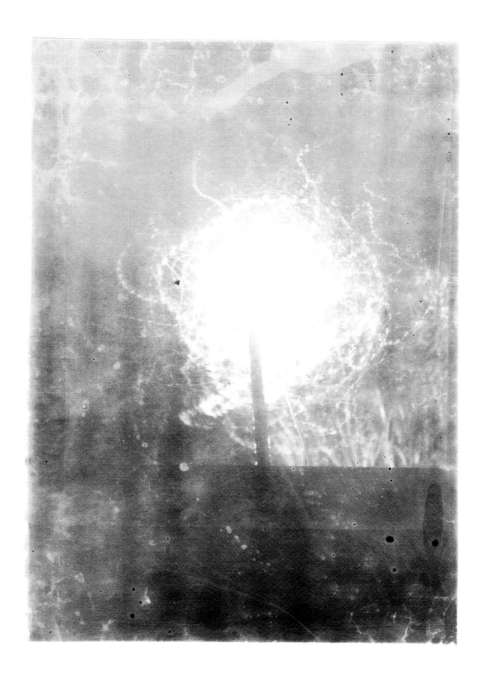

PLATE 69. Emmet Gowin, *Pale Light and Insect Flight*, 2001

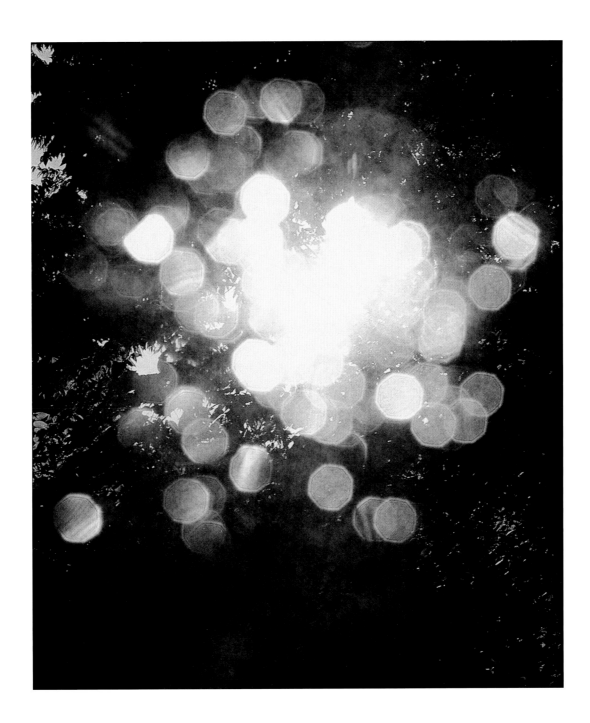

PLATE 70. Elijah Gowin, *Into the Sun 41*, 2009

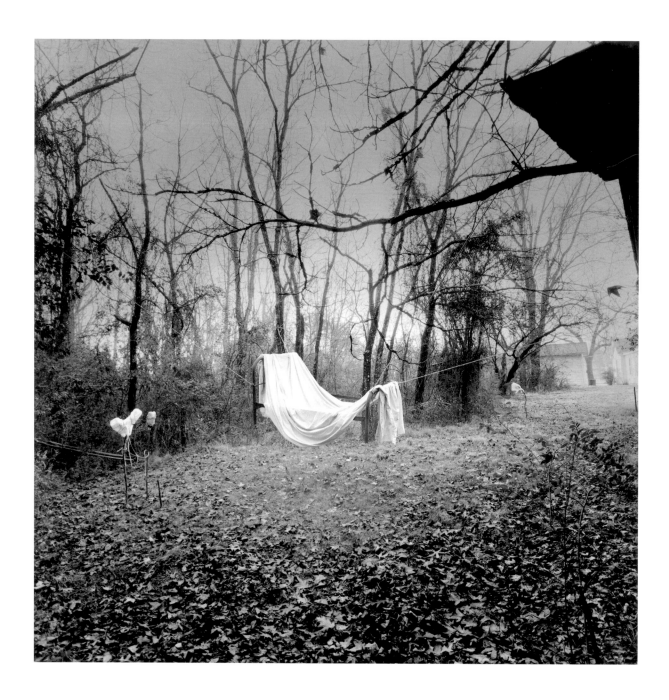

PLATE 71. Elijah Gowin, *Great Grandmother's Bed*, 1998

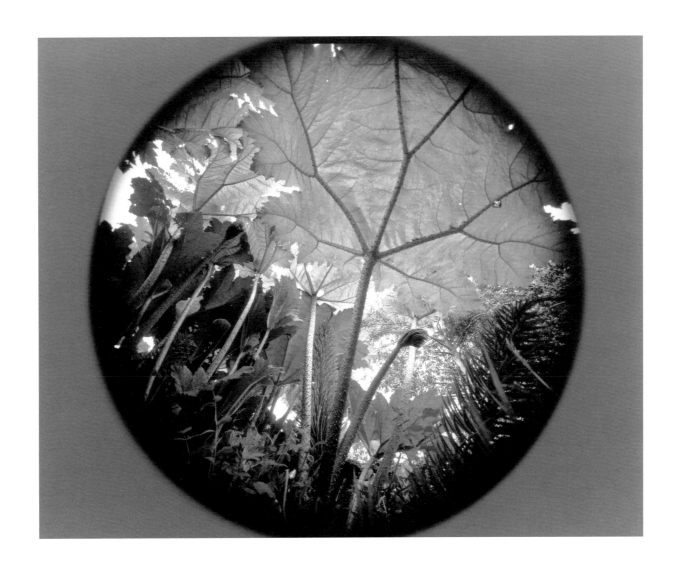

PLATE 72. Emmet Gowin, *Ireland*, 1972

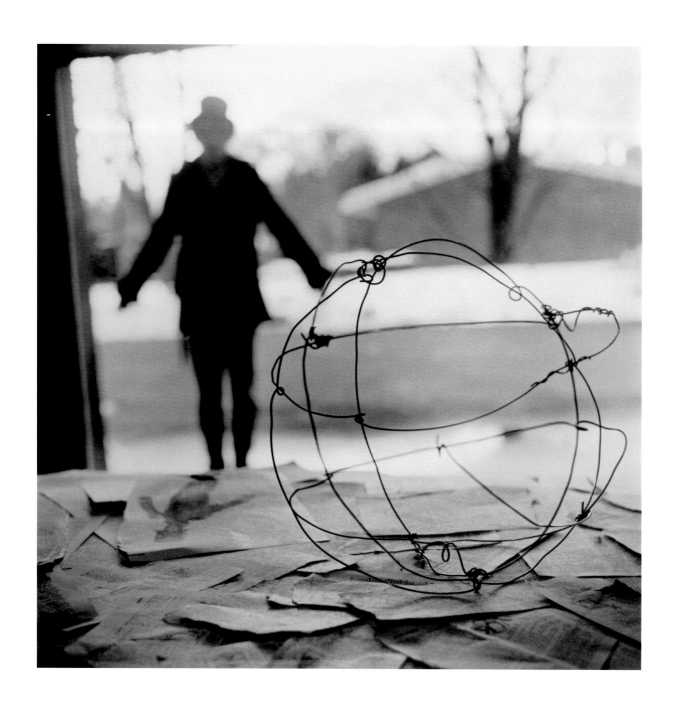

PLATE 73. Elijah Gowin, *Globe*, 2002

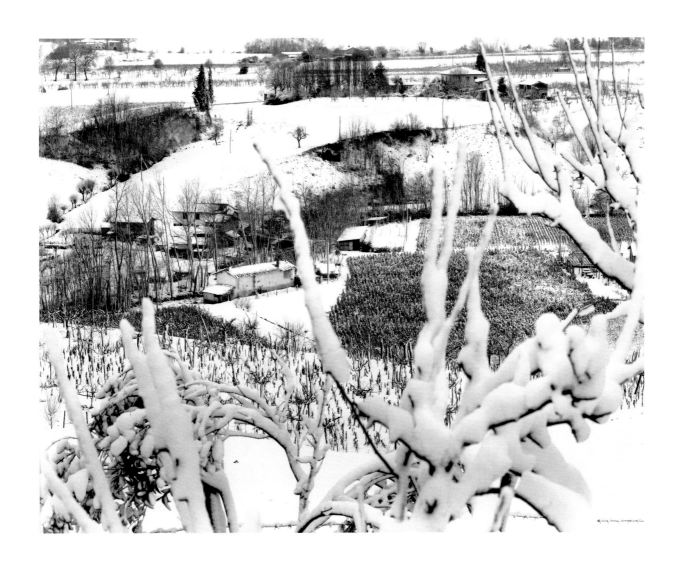

PLATE 74. Emmet Gowin, *Scarperia, Italy*, 1981

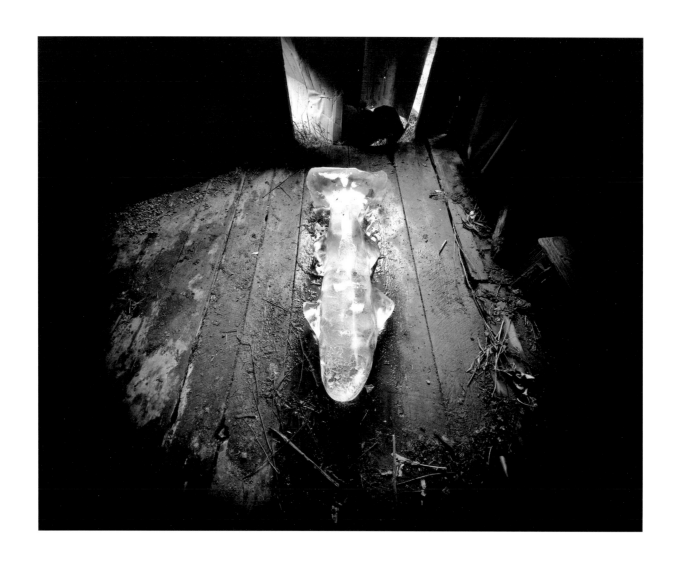

PLATE 75. Emmet Gowin, *Ice Fish, Danville, Virginia*, 1971

PLATE 76. Takayuki Ogawa, *Untitled 11*, 1995–97

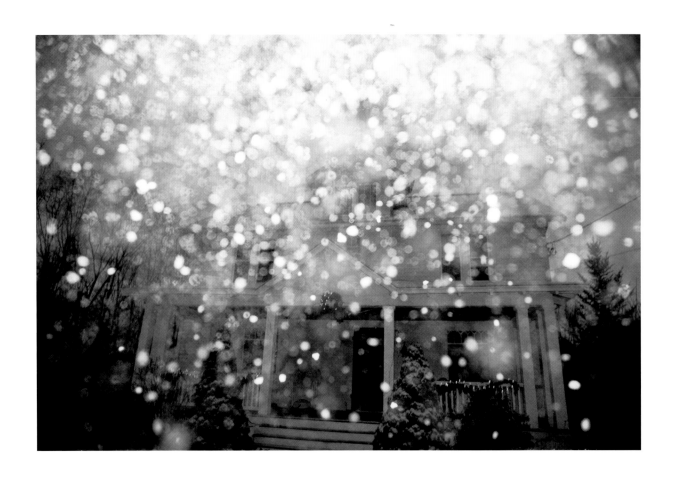

PLATE 77. Elijah Gowin, *House 1*, 2014

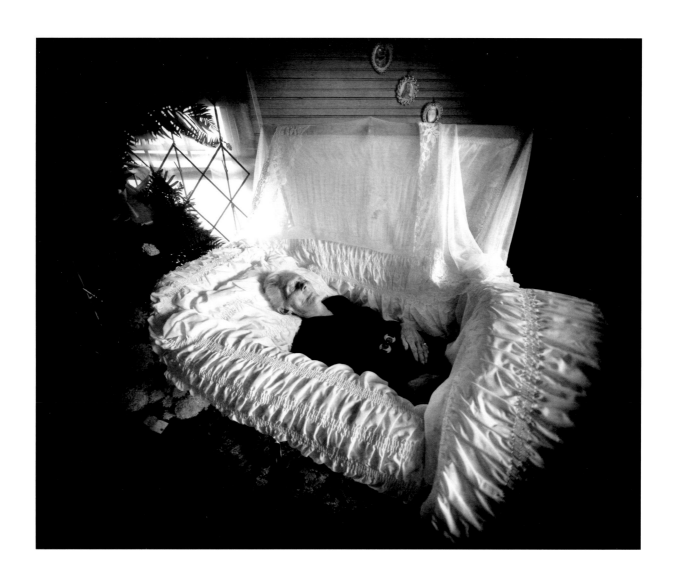

PLATE 78.  Emmet Gowin, *Rennie Booher, Danville, Virginia,* 1972

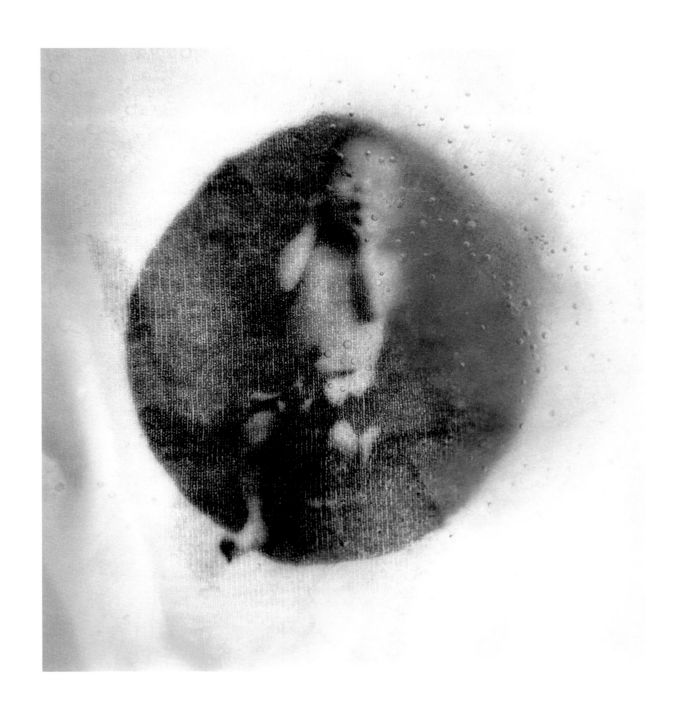

Hikari

PLATE 79. Osamu James Nakagawa, *Hikari, Bloomington, Indiana*, Winter 1998

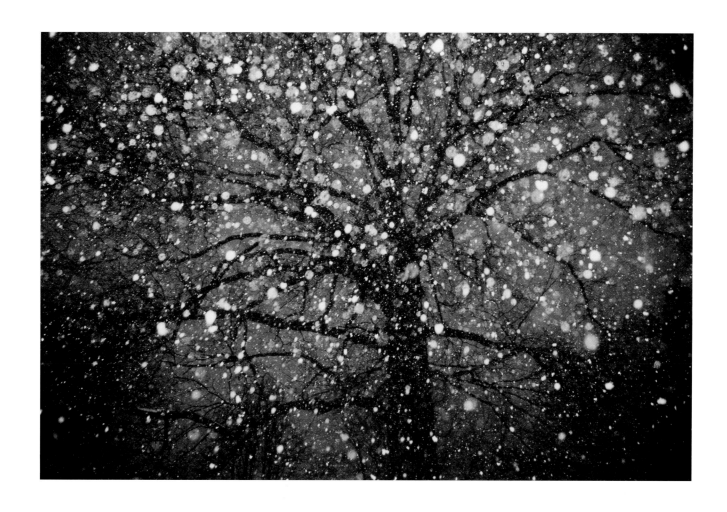

PLATE 80. Elijah Gowin, *Tree 1*, 2012

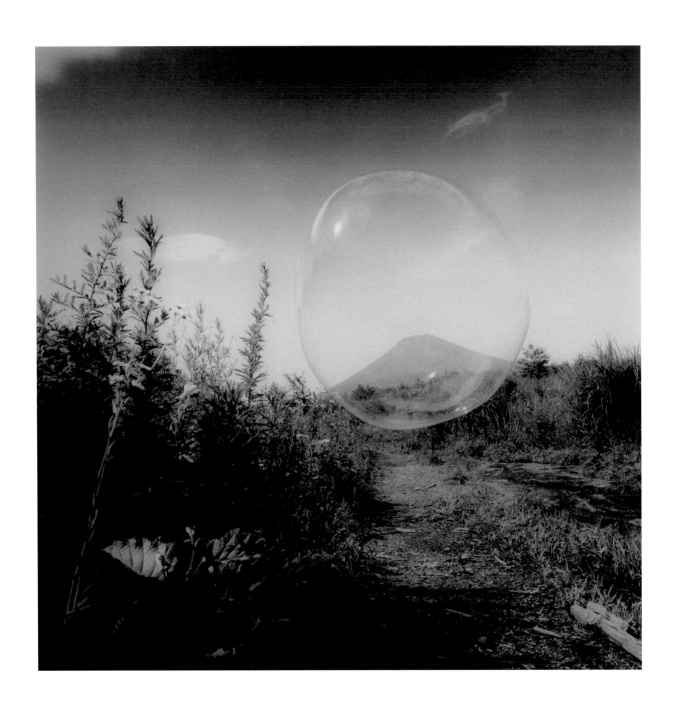

PLATE 81. Osamu James Nakagawa, *Mt. Fuji, Japan*, Summer 1999

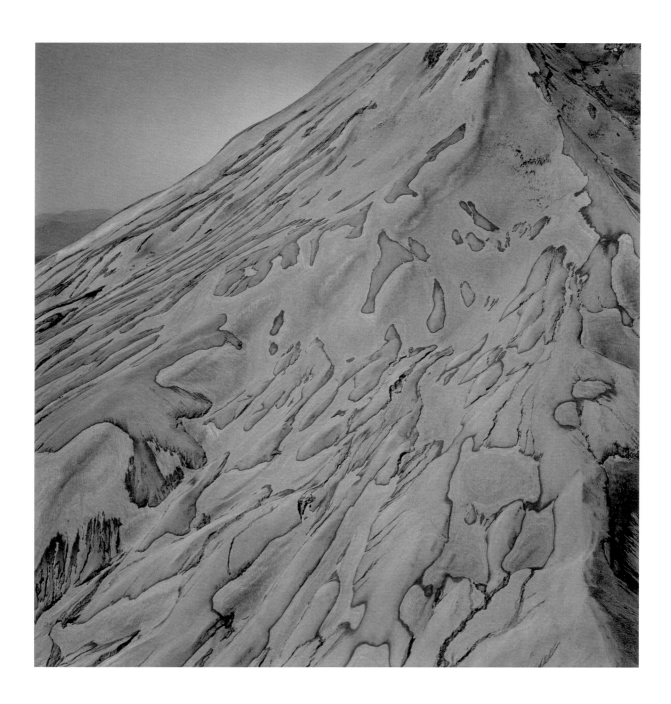

PLATE 82. Emmet Gowin, *Mount St. Helens, Washington*, 1982

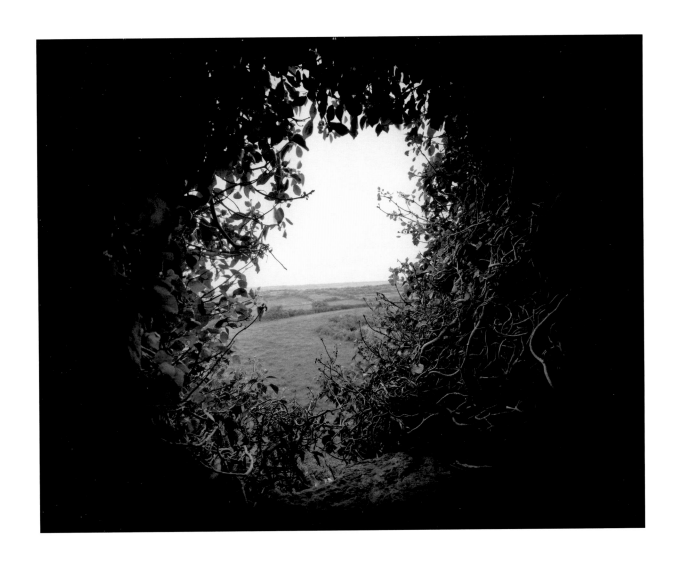

PLATE 83. Emmet Gowin, *Ireland*, 1982

# CHECKLIST

1. Emmet Gowin
   *Edith and Rennie Booher, Danville,*
   *Virginia*
   1969
   Gelatin silver print
   5½ x 7 in. (13.9 x 17.7 cm)

2. Osamu James Nakagawa
   *Kai Ninomiya, Japan*
   Autumn 1998
   Gelatin silver print
   14 x 14 in. (35.5 x 35.5 cm)
   No. 1 from the series *Kai:*
   *Following the Cycle of Life*

3. Emmet Gowin
   *Edith and Isaac, Newton, Pennsylvania*
   1974
   Gelatin silver print
   6½ x 6½ in. (16.5 x 16.5 cm)

4. Osamu James Nakagawa
   *Tomoko's Gaze, New York*
   Autumn 1999
   Gelatin silver print
   14 x 14 in. (35.5 x 35.5 cm)
   No. 35 from the series *Kai: Following*
   *the Cycle of Life*

5. Elijah Gowin
   *Bubble Baby*
   2002
   Toned gelatin silver print
   15 x 15 in. (38.1 x 38.1 cm)
   Unique print courtesy of
   Robert Mann Gallery

6. Osamu James Nakagawa
   *Morning Light, Bloomington, Indiana*
   Spring 1999
   Gelatin silver print
   14 x 14 in. (35.5 x 35.5 cm)
   No. 17 from the series *Kai: Following*
   *the Cycle of Life*

7. Elijah Gowin
   *Cocoon*
   2002
   Toned gelatin silver print
   19 x 23 in. (48.2 x 58.4 cm)
   Unique print courtesy of Robert
   Mann Gallery

8. Emmet Gowin
   *Edith and Elijah, Danville, Virginia*
   1968
   Gelatin silver print
   5½ x 7 in. (13.9 x 17.7 cm)

9. Emmet Gowin
   *Family, Danville, Virginia*
   1970
   Gelatin silver print
   5½ x 7 in. (13.9 x 17.7 cm)

10. Elijah Gowin
    *Game*
    2001
    Toned gelatin silver print
    15 x 19 in. (38.1 x 48.2 cm)
    Unique print courtesy of Robert
    Mann Gallery

11. Osamu James Nakagawa
    *Curtain, Tokyo, Japan*
    Spring 2013
    Archival pigment print
    14 x 14 in. (35.5 x 35.5 cm)
    No. 71 from the series *Kai: Following*
    *the Cycle of Life*

12. Emmet Gowin
    *Edith and Elijah, Danville, Virginia*
    1968
    Gelatin silver print
    5½ x 7 in. (13.9 x 17.7 cm)

13. Elijah Gowin
    *Cage*
    1999
    Toned gelatin silver print
    15 x 15 in. (38.1 x 38.1 cm)
    Unique print courtesy of Robert
    Mann Gallery

14. Osamu James Nakagawa
    *Piñata, Bloomington, Indiana*
    Spring 2004
    Archival pigment print
    14 x 14 in. (35.5 x 35.5 cm)
    No. 47 from the series *Kai: Following*
    *the Cycle of Life*

15. Osamu James Nakagawa
    *Dahlia, Tokyo, Japan*
    Spring 2013
    Archival pigment print
    14 x 14 in. (35.5 x 35.5 cm)
    No. 62 from the series *Kai: Following*
    *the Cycle of Life*

16. Osamu James Nakagawa
    *Contact, Tokyo, Japan*
    Spring 2013
    Archival pigment print
    14 x 14 in. (35.5 x 35.5 cm)
    No. 58 from the series *Kai: Following*
    *the Cycle of Life*

17. Takayuki Ogawa
    *Untitled 06*
    1995–97
    Gelatin silver prints
    10 x 10 in. (25.4 x 25.4 cm) each
    From the series *Beyond the Mirror:*
    *A Self-Portrait*

18. Takayuki Ogawa
*Untitled 02*
1995–97
Gelatin silver prints
Top row: 4 x 5 in. (10.1 x 12.7 cm)
each; bottom row: 18¼ x 7¼ in.
(46.3 x 18.4 cm)
From the series *Beyond the Mirror:
A Self-Portrait*

19. Takayuki Ogawa
*Untitled 14*
1995–97
Gelatin silver print
19¼ x 15¼ in. (48.8 x 38.7 cm)
From the series *Beyond the Mirror:
A Self-Portrait*

20. Elijah Gowin
*Violet Catching Firefly, Danville, Virginia*
2016
Archival pigment inkjet print
30¾ x 22 in. (78.1 x 55.8 cm)
Courtesy of Robert Mann Gallery

21. Emmet Gowin
*Nancy, Danville, Virginia*
1969
Gelatin silver print
5½ x 7 in. (13.9 x 17.7 cm)

22. Osamu James Nakagawa
*Bathing, Bloomington, Indiana*
Summer 1999
Gelatin silver print
14 x 14 in. (35.5 x 35.5 cm)
No. 28 from the series *Kai: Following
the Cycle of Life*

23. Elijah Gowin
*Falling in Trees 6*
2007
Varnished pigment inkjet print
14 x 12 in. (35.5 x 30.4 cm)
Courtesy of Robert Mann Gallery

24. Emmet Gowin
*Elijah and Donna Jo, Danville, Virginia*
1971
Gelatin silver print
6½ x 6½ in. (16.5 x 16.5 cm)

25. Osamu James Nakagawa
*Airplane (Takai Takai), Bloomington,
Indiana*
Winter 2001
Gelatin silver print
14 x 14 in. (35.5 x 35.5 cm)
No. 43 from the series *Kai: Following
the Cycle of Life*

26. Elijah Gowin
*Gasp 1*
2005
Varnished pigment inkjet print
22 x 28 in. (55.8 x 71.1 cm)
Courtesy of Robert Mann Gallery

27. Osamu James Nakagawa
*Father's Hands, Bloomington, Indiana*
Winter 1999
Gelatin silver print
14 x 14 in. (35.5 x 35.5 cm)
No. 13 from the series *Kai: Following
the Cycle of Life*

28. Elijah Gowin
*Falling in Trees 14*
2007
Varnished pigment inkjet print
40 x 34 in. (101.6 x 86.3 cm)
Courtesy of Robert Mann Gallery

29. Emmet Gowin
*Barry and Dwayne, Danville, Virginia*
1971
Gelatin silver print
6½ x 6½ in. (16.5 x 16.5 cm)

30. Osamu James Nakagawa
*Frozen Jacket, Bloomington, Indiana*
Winter 1998
Gelatin silver print
14 x 14 in. (35.5 x 35.5 cm)
No. 27 from the series *Kai: Following
the Cycle of Life*

31. Emmet Gowin
*Maggie and Darlene, Danville, Virginia*
1971
Gelatin silver print
6½ x 6½ in. (16.5 x 16.5 cm)

32. Takayuki Ogawa
*Untitled 21*
1995–97
Gelatin silver print
16 x 19 in. (40.6 x 48.2 cm)
From the series *Beyond the Mirror:
A Self-Portrait*

33. Takayuki Ogawa
*Untitled 17*
1995–97
Gelatin silver print
15 x 15 in. (38.1 x 38.1 cm)
From the series *Beyond the Mirror:
A Self-Portrait*

34. Osamu James Nakagawa
*Tomoko, Houston, Texas*
Spring 1998
Gelatin silver print
14 x 14 in. (35.5 x 35.5 cm)
No. 11 from the series *Kai: Following
the Cycle of Life*

35. Emmet Gowin
*Edith and Moth Flight*
2002
Digital inkjet Ultrachrome print
11 x 11 in. (27.9 x 27.9 cm)

36. Elijah Gowin
*Maggie and Orbs*
2001
Toned gelatin silver print
15 x 19 in. (38.1 x 48.2 cm)
Unique print courtesy of
Robert Mann Gallery

37. Osamu James Nakagawa
*Hands, Tokyo, Japan*
Spring 2013
Archival pigment print
14 x 14 in. (35.5 x 35.5 cm)
No. 66 from the series *Kai: Following the Cycle of Life*

38. Elijah Gowin
*Nest*
2001
Toned silver gelatin print
15 x 19 in. (38.1 x 48.2 cm)
Unique print courtesy of
Robert Mann Gallery

39. Takayuki Ogawa
*Untitled 05*
1995–97
Gelatin silver print
19½ x 10 in. (49.5 x 25.4 cm)
From the series *Beyond the Mirror: A Self-Portrait*

40. Emmet Gowin
*Sedan Crater, Northern End of Yucca Flat, Nevada Test Site*
1996
Toned gelatin silver print

41. Osamu James Nakagawa
*Leaving Tokyo, Japan*
Winter 2011
Archival pigment print
14 x 14 in. (35.5 x 35.5 cm)
No. 57 from the series *Kai: Following the Cycle of Life*

42. Elijah Gowin
*Fiona on Porch with Firefly, Danville, Virginia*
2016
Archival pigment inkjet print
30¾ x 22 in. (78.1 x 55.8 cm)

43. Elijah Gowin
*Fire 4*
2009
Varnished pigment inkjet print
34 x 40 in. (86.3 x 101.6 cm)
Courtesy of Robert Mann Gallery

44. Elijah Gowin
*Into the Sun 26*
2009
Varnished pigment inkjet print
26 x 22 in. (66 x 55.8 cm)
Courtesy of Robert Mann Gallery

45. Takayuki Ogawa
*Untitled 20*
1995–97
Gelatin silver print
15¼ x 16¼ in. (38.7 x 41.2 cm)
From the series *Beyond the Mirror: A Self-Portrait*

46. Takayuki Ogawa
*Untitled 01*
1995–97
Gelatin silver prints
Top row: 18½ x 7½ in. (46.9 x 19 cm);
bottom row: 4½ x 7½ in.
(11.4 x 19) each
From the series *Beyond the Mirror: A Self-Portrait*

47. Osamu James Nakagawa
*Final Conversation, Tokyo, Japan*
Spring 2013
Archival pigment print
14 x 14 in. (35.5 x 35.5 cm)
No. 103 from the series *Kai: Following the Cycle of Life*

48. Osamu James Nakagawa
*Stockings, Ninomiya, Japan*
Spring 2013
Archival pigment print
14 x 14 in. (35.5 x 35.5 cm)
No. 59 from the series *Kai: Following the Cycle of Life*

49. Elijah Gowin
*Into the Sun 40*
2009
Varnished pigment inkjet print
26 x 22 in. (66 x 55.8 cm)
Courtesy of Robert Mann Gallery

50. Takayuki Ogawa
*Untitled 13*
1995–97
Gelatin silver print
14½ x 17½ in. (36.8 x 44.4 cm)
From the series *Beyond the Mirror: A Self-Portrait*

51. Elijah Gowin
*Divide 1*
2006
Varnished pigment inkjet print
34 x 40 in. (86.3 x 101.6 cm)
Courtesy of Robert Mann Gallery

52. Emmet Gowin
*Edith in Panama, Deep Violet*
2005
Unique gold-toned salt print on
handmade paper
15 x 10¾ in. (38.1 x 27.3 cm)

53. Osamu James Nakagawa
*Gold Fishes, Bloomington, Indiana*
Winter 2000
Gelatin silver print
14 x 14 in. (35.5 x 35.5 cm)
No. 32 from the series *Kai: Following the Cycle of Life*

54. Takayuki Ogawa
*Untitled 18*
1995–97
Gelatin silver print
15 x 16¼ in. (38.1 x 41.2 cm)
From the series *Beyond the Mirror:*
*A Self-Portrait*

55. Osamu James Nakagawa
*Hot Springs, Hakone, Japan*
Summer 1998
Gelatin silver print
14 x 14 in. (35.5 x 35.5 cm)
No. 04 from the series *Kai: Following*
*the Cycle of Life*

56. Elijah Gowin
*Eye Holes*
2001
Toned gelatin silver print
15 x 19 in. (38.1 x 48.2 cm)
Unique print courtesy of Robert
Mann Gallery

57. Takayuki Ogawa
*Untitled 12*
1995–97
Gelatin silver prints
10¼ x 13 in. (26 x 33 cm) each
From the series *Beyond the Mirror:*
*A Self-Portrait*

58. Takayuki Ogawa
*Untitled 15*
1995–97
Gelatin silver print
7½ x 9½ in. (19 x 24.1 cm)
From the series *Beyond the Mirror:*
*A Self-Portrait*

59. Takayuki Ogawa
*Untitled 16*
1995–97
Gelatin silver print
15 x 17 in. (38.1 x 43.1 cm)
From the series *Beyond the Mirror:*
*A Self-Portrait*

60. Takayuki Ogawa
*Untitled 07*
1995–97
Gelatin silver print
10¼ x 13 in. (26 x 33 cm)
From the series *Beyond the Mirror:*
*A Self-Portrait*

61. Osamu James Nakagawa
*Mother's Back, Tokyo*
Summer 2010
Archival pigment print
14 x 14 in. (35.5 x 35.5 cm)
No. 56 from the series *Kai: Following*
*the Cycle of Life*

62. Takayuki Ogawa
*Untitled 10*
1995–97
Gelatin silver prints
10 x 10 in. (25.4 x 25.4 cm) each
From the series *Beyond the Mirror:*
*A Self-Portrait*

63. Emmet Gowin
*Edith in Panama, Double Edith*
*and Rothschildia*
2003
Unique gold-toned salt print on
Arches paper
15 x 10¾ in. (38.1 x 27.3 cm)

64. Takayuki Ogawa
*Untitled 22*
1995–97
Gelatin silver print
9 x 12 in. (22.8 x 30.4 cm)
From the series *Beyond the Mirror:*
*A Self-Portrait*

65. Emmet Gowin
*View of Rennie Booher's House,*
*Danville, Virginia*
1973
Gelatin silver print
7⅝ x 9⅝ in. (19.3 x 24.4 cm)

66. Elijah Gowin
*Into the Sun 37*
2009
Varnished pigment inkjet print
26 x 22 in. (66 x 55.8 cm)
Courtesy of Robert Mann Gallery

67. Emmet Gowin
*Edith in Panama, Leaf Mask*
2004
Unique gold-toned salt print on
Richard de Bas paper
15¼ x 10¾ in. (38.7 x 27.3 cm)

68. Osamu James Nakagawa
*Blood, Kyoto, Japan*
Summer 2014
Archival pigment print
14 x 14 in. (35.5 x 35.5 cm)
No. 99 from the series *Kai: Following*
*the Cycle of Life*

69. Emmet Gowin
*Pale Light and Insect Flight*
2001
Unique gold-toned salt print on
handmade paper
15¼ x 11¼ in. (38.7 x 28.5 cm)
Richard and Ronay Menschel
Collection, New York

70. Elijah Gowin
*Into the Sun 41*
2009
Varnished pigment inkjet print
26 x 22 in. (66 x 55.8 cm)
Courtesy of Robert Mann Gallery

71. Elijah Gowin
*Great Grandmother's Bed*
1998
Toned gelatin silver print
15 x 15 in. (38.1 x 38.1 cm)
Unique print courtesy of Robert
Mann Gallery

72. Emmet Gowin
*Ireland*
1972
Gelatin silver print
7⅝ x 9⅝ in. (19.3 x 24.4 cm)

73. Elijah Gowin
*Globe*
2002
Toned silver gelatin print
15 x 15 in. (38.1 x 38.1 cm)
Unique print courtesy of
Robert Mann Gallery

74. Emmet Gowin
*Scarperia, Italy*
1981
Gelatin silver print
7½ x 9½ in. (19 x 24.1 cm)

75. Emmet Gowin
*Ice Fish, Danville, Virginia*
1971
Gelatin silver print
7½ x 9½ in. (19 x 24.1 cm)

76. Takayuki Ogawa
*Untitled 11*
1995–97
Gelatin silver prints
10½ x 11 in. (26.6 x 27.9 cm) each

77. Elijah Gowin
*House 1*
2014
Archival pigment inkjet print
15⅓ x 23 in. (38.9 x 58.4 cm)
Courtesy of Robert Mann Gallery

78. Emmet Gowin
*Rennie Booher, Danville, Virginia*
1972
Gelatin silver print
7½ x 9½ in. (19 x 24.1 cm)

79. Osamu James Nakagawa
*Hikari, Bloomington, Indiana*
Winter 1998
Gelatin silver print
14 x 14 in. (35.5 x 35.5 cm)
No. 3 from the series *Kai: Following
the Cycle of Life*

80. Elijah Gowin
*Tree 1*
2012
Archival pigment inkjet print
22 x 34 in. (55.8 x 86.3 cm)
Courtesy of Robert Mann Gallery

81. Osamu James Nakagawa
*Mt. Fuji, Japan*
Summer 1999
Gelatin silver print
14 x 14 in. (35.5 x 35.5 cm)
No. 31 from the series *Kai: Following
the Cycle of Life*

82. Emmet Gowin
*Mount St. Helens, Washington*
1982
Gelatin silver print
10 x 10 in. (25.4 x 25.4 cm)

83. Emmet Gowin
*Ireland*
1982
Gelatin silver print
7⅝ x 9⅝ in. (19.3 x 24.4 cm)

# ABOUT THE ARTISTS

**Elijah Gowin** (b. Dayton, Ohio, 1967) received a BA in art history from Davidson College in 1990 and an MFA from the University of New Mexico in 1996. He has taught photography and digital imaging since 1995 and is a professor in the Department of Art and Art History at the University of Missouri-Kansas City where he directs photographic studies. He is the recipient of several awards, including a John Simon Guggenheim Foundation Fellowship in 2008 and a Puffin Foundation Grant in 2007. He has lectured extensively about his work and exhibited in solo and group exhibitions at many venues, including the Houston Center for Photography; the Virginia Museum of Contemporary Art; the Corcoran Museum of Art, Washington, DC; Griffin Museum of Photography, Winchester, Massachusetts; and locations in China, Japan, and Spain. His work is in the collections of the Museum of Fine Arts, Houston; the Los Angeles County Museum of Art; Center for Creative Photography, Tucson, Arizona; and the International Center of Photography at George Eastman House. Gowin is represented by the Robert Mann Gallery, New York; Page Bond Gallery, Richmond, Virginia; and PGI, Tokyo, Japan.

**Emmet Gowin** (b. Danville, Virginia, 1941) is widely regarded as among the most original and influential photographers of his generation. Gowin received an MFA in photography from the Rhode Island School of Design in 1967 and taught in the visual arts program at Princeton University from 1973 to 2009. Traveling exhibitions of his photographs have been organized by the Philadelphia Museum of Art (1990–93), Yale University Art Gallery (2002–04), and the Fundación MAPFRE, Madrid (2012–14). In the spring and fall of 2014 Gowin studied objects from all areas of the collection of the Morgan Library & Museum, then selected some fifty pieces to exhibit alongside representative works from his five decades in photography. Gowin is represented by Pace McGill, New York, and PGI, Tokyo, Japan.

**Osamu James Nakagawa** (b. New York, New York, 1962) was raised in Tokyo, Japan, and moved to Houston, Texas, at the age of fifteen. He received an MFA from the University of Houston in 1993. Nakagawa is the Ruth N. Halls Professor of Art at Indiana University, and was a 2009 Guggenheim Fellow, the 2010 Higashikawa New Photographer of the Year, and the 2015 Sagamihara Photographer of the Year in Japan. His monograph *GAMA Caves* was published by Akaaka Art Publishing in January 2014. Nakagawa's recent work, from the *BANTA* and *GAMA* series, was shown at the Metropolitan Museum of Art; Museum of Fine Arts, Houston; 2012 Les Rencontre D'Arles, France; Fries Museum, the Netherlands; Nikon Salon, Tokyo; and others. His work is in the permanent collections of the Metropolitan Museum of Art, New York; the International Center of Photography at George Eastman House; Tokyo Metropolitan Museum of Photography; Museum of Fine Arts, Houston; Sakima Art Museum, Okinawa; the Museum of Contemporary Photography Chicago; and Nelson-Atkins Museum of Art, Kansas City. Nakagawa is represented by SepiaEYE, New York; Pictura Gallery, Bloomington, Indiana; and PGI, Tokyo, Japan.

**Takayuki Ogawa** (1936–2008) was a highly esteemed photographer in Japan who contributed to both art and commercial photography. He received a BA in photography from Nihon University in Tokyo. Ogawa subsequently worked as a photojournalist for the magazine *Weekly Bunsuhn*, before becoming a freelance photographer. Trips to the former USSR and the United States in the mid- to late 1960s helped further his artistic recognition abroad. Beginning in 1968, Ogawa worked in both journalistic and commercial photography and film. He received the 1968 New Photographer of the Year Award from the Association of Japan Photography Critics and he was given an award from the Art Directors Club of Tokyo in 1982. With his debut photographic project, *NEW YORK IS*, Ogawa became the first Japanese photographer to mount a solo exhibition at the George Eastman House in 1969. The same year, he was also featured in a major survey exhibition, *Vision and Expression*, curated by Nathan Lyons. Ogawa exhibited *Beyond the Mirror: A Self-Portrait,* a series exploring his experience with serious illness, medical treatment, and recovery, at the Houston Center for Photography in 1998. His work is represented in numerous collections, including the International Center of Photography at George Eastman House, Tokyo Metropolitan Museum of Photography, and Museum of Fine Arts, Houston. Ogawa is represented by Akio Nagasawa Gallery, Tokyo, Japan.